THE LUCK ARCHIVE

THE LUCK ARCHIVE

EXPLORING BELIEF, SUPERSTITION, AND TRADITION

MARK MENJIVAR

FOREWORD BY HARRELL FLETCHER

Trinity University Press
San Antonio, Texas

Luck is a thing that comes in many forms and who can recognize her?

– Ernest Hemingway, *The Old Man and the Sea*

LUCK

HARRELL FLETCHER

There was a time in my life, a couple of years in my late twenties, when I got a little obsessed with finding "lucky pennies." The pennies had to be found face up on the street or sidewalk, and I would always put them in my right back pocket. I felt like things would go well for me when I was in possession of one of these pennies, so I was always on the lookout. When something important was about to happen or I was waiting for news of some kind, I would walk around frantically looking for a faceup penny. I would relax only when I found one. Eventually I decided the practice was going too far. I didn't really believe in superstitions, so I decided to break my lucky penny habit. It took a while, but eventually I did, and so far there have been no major changes in my fortune one way or another.

There continue to be other persistent examples of superstition that I haven't dismissed. One is particular to the small agricultural town of Santa Maria, California, where I grew up. At some point before I was born and prior to the construction of Twitchell Dam, water flowed in the Santa Maria River. The riverbed, now dry, is the dividing line between Santa Barbara and San Luis Obispo Counties. When we were children, my older sister Martha told me that if you held your breath while driving over the bridge that connects the two counties, you could make a wish at the end. Not only have I happily continued this practice, but I've shared it with my young daughter on the rare occasions when we've been back to Santa Maria together. I like the aspect of minor physical endurance to

the wish-granting situation—you have to earn it. There is also the unspoken sense that if you don't hold your breath the whole time (the bridge is just long enough, maybe a quarter mile, to be a slight challenge, especially for a kid) something unlucky might happen. I think the main reason I like the bridge wish process is that it gives me a moment to ponder, as I'm entering or exiting my hometown, what I want to have happen in life, at least for that moment. Many wishes from the past have been about family wellbeing, though few family members still live there and my sister Martha has been dead for over a decade.

Another superstition I contend with is the number 13. I don't recall when I learned the number was bad luck, but it has cropped up for me in all sorts of situations. As far as I can tell, it has never caused me harm, but I have a hard time seeing it as neutral. Recently, while going through a horrific divorce and custody battle, I switched lawyers and then discovered that the new one's office was on the thirteenth floor of an office building. Things were already looking bad, but I decided to get past my psychological concerns and move forward. The situation turned around and concluded favorably (other than all of the money spent on legal bills), so perhaps I need to reconsider, or relinquish, the sense of power—as I did with my former lucky pennies—that I have given the number 13.

My father always told me to think positive thoughts. He had an anecdotal story of using his positive mind power in his twenties to cure a case of potentially fatal stomach ulcers. He believed that positive visualization could achieve anything but mostly suggested I use it for hitting home runs when I played Little League. I did hit a lot of home runs, but it's hard to say exactly what positive

thinking had to do with it. Could luck be somehow manifested through intention, and could lucky objects, traditions, and rituals be ways we formalize that intention? I've heard that people who consider themselves lucky lead happier, more fulfilled lives than people who don't, or than people who don't believe in luck at all. But what about all of those rabbit foot–rubbing slot machine players who lose all their money again and again? I suppose this is part of the intrigue about an abstract and subjective idea like luck: it's transient and inconsistent at best.

Mark's idea to develop an archive about luck is intriguing. It reminds me of the list of statistics I saw at a Vietnamese war memorial museum that included among the number of dead and wounded a line about how many old people were left lonesome because of the loss of their loved ones. The number seemed hard to verify, but the sense that these people existed and suffered was made real by the attempt to quantify it. So it goes with luck. The exact whats and whys and ways of it are impossible to pin down, but Mark's efforts to classify them still help us grasp its elusive mysteries. He uses participatory methods and a variety of forms to create a collection that didn't exist before except in its nebulous parts. I recall a similar impulse with a web-based project that I produced with Miranda July and web designer Yuri Ono in the early 2000s. The project, called Learning To Love You More, asked the public to respond to "assignments," seventy in all, that Miranda and I came up with—for example, "Take a flash photo under your bed," "Describe what to do with your body after you are dead," and "Record the sound that is keeping you awake"—and to turn in a "report" to be accumulated and shared with the public on our website. Through this process,

which relied heavily on the generous contributions of people from all over the world, we were able to create archives on topics that we were interested in but that we couldn't find anywhere else. In a similar way Mark has created something from nothing, and about something that may be nothing, or may be more important than we could have known had he not made it for us.

Mark's work in general uses photography (and various other media and approaches) to explore aspects of life that are normally hidden from view. He functions as an unorthodox documentarian, one with agency to affect and activate the people and subjects he documents. In the past this kind of intervention was considered against the rules of documentation; lines were drawn, at least theoretically, between photographer, subject, and audience. But now, especially with the advent and acceptance of socially engaged art practices, it is possible to operate transparently, as Mark does, in more involved, inclusive, and participatory ways. Mark has used his practice to investigate everything from the food in people's refrigerators to the effects of civil war in El Salvador.

The book in your hands is just one incarnation of the ongoing Luck Archive. I look forward to seeing how this project and Mark's other endeavors continue to confront, reveal, and connect into the future.

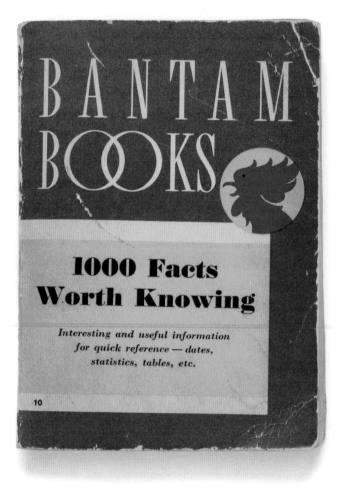

BANTAM BOOKS

1000 Facts Worth Knowing

Interesting and useful information
for quick reference — dates,
statistics, tables, etc.

10

INTRODUCTION

MARK MENJIVAR

A few years ago I walked into the Hyde Brothers bookstore in Fort Wayne, Indiana, and found a small book from the 1940s called *1000 Facts Worth Knowing*. When I opened it, I discovered 4 four-leaf clovers pressed between the pages.

Finding the clovers made me begin to think about luck in my own life. As a middle school basketball player I believed it was bad luck to put my right shoe on first. To this day I still put on my left shoe before my right—and I do the same with my kids' shoes. About the same time a girl told me it was incredibly lucky to look at a clock when it read 11:11 and that you should make a wish right away. The more I thought about luck critically, though, the more I questioned whether it even existed.

On a plane flight back from a trip I started talking with the man sitting next to me. After some small talk, I asked what he thought about luck. He told me that when he was in his twenties he was in a horrible motorcycle accident and wasn't supposed to survive. In his thirties he was a high school shop teacher, and one of his students inserted a wood board incorrectly into a machine. The board went flying across the room and struck him in the forehead, shattering his skull. It took him more than a year to recover. He turned his neck to the side and showed me a deep scar—what remained from a recent battle with cancer. "My family says I'm the luckiest person alive," he said. Without missing a beat, I told him that to me he sounded like the unluckiest person alive. We had a good laugh about it and continued talking for the rest of the flight.

I decided I wanted to explore how luck intersected with belief, culture, superstition, and tradition in people's lives and in our society. I photographed each of the four clovers I'd found in the book and made 250 4 x 5 contact prints of each to give to people I met along the way.

While each part of my exploration has been interesting on its own, I became fascinated by the diversity of people's experiences when the pieces were placed next to each other. I started organizing the stories, objects, and photographs into a publicly accessible collection called the Luck Archive. So far the archive contains more than 450 entries that include rings, coins, clovers, charms, patches, underwear, sports superstitions, lottery strategies, day trader insights, animal stories, dolls, games, crystals, seeds, cigarettes, rainbows, and more.

I've talked with people on the streets; in supermarkets, airplanes, baseball stadiums, botánicas, and museums; over dinners; and standing in line. Some people discuss luck prescriptively, describing the things they do to gain good luck or avoid bad. Some of these things have been passed down from generations before, and others were learned on playgrounds or in locker rooms. Other people talk about luck descriptively, using the word to make sense of what has happened to them or someone they know.

People frequently mention finding lucky pennies. Pigs, often sold as trinkets in shops, are considered lucky in many cultures. And I have lost count of the number of horseshoes I've seen nailed to the exterior or interior of homes. Many people share my belief about 11:11–and at one point in the project I invited people to send me their images taken at exactly this time. Over 100 have come in so far.

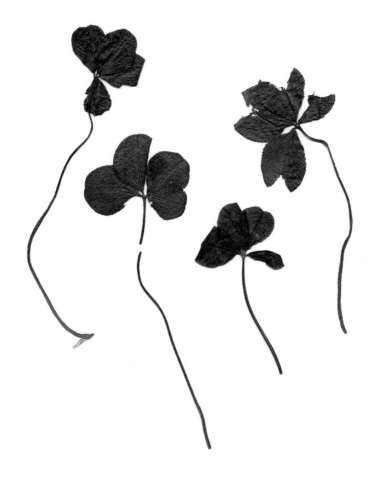

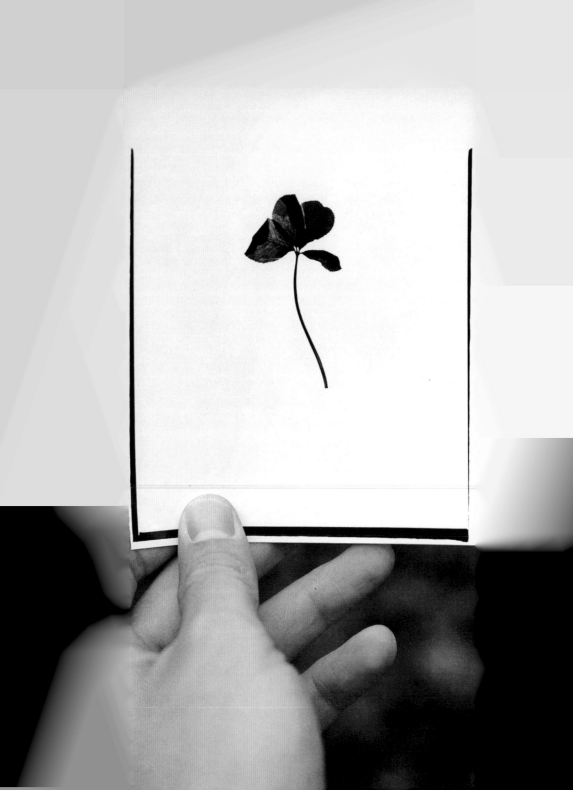

Parts of the archive are a bit more mysterious and invite us to find a place to hang our own stories. A photograph of the U.S. Border Patrol invokes the role luck plays in numerous, often treacherous tales of immigration. A dead skunk helps us consider chance encounters from a variety of perspectives, and a smashed mailbox points to the way human intervention can affect our luck narratives. For me, these types of submissions are a starting point for our own imaginations.

One day I was touring an artisan's workshop with my friend Jason. In the course of telling us about his craft, the owner said at least three times that he did not believe in luck. Jason mentioned that I was working on a project about luck and urged me to tell him about it. The owner said the project seemed interesting and reemphasized his disbelief. I said I wasn't trying to convert anyone to a certain perspective and then asked how he acquired the beautiful building we were standing in. The first words out of his mouth were "I got really lucky!"

I tell this story not to try to make the owner look bad but to show how the concept of luck can enter our lives whether or not we believe in it. Almost everyone can connect to luck in one way or another. We each have a different definition and understanding of what it means.

This book contains only a portion of the Luck Archive. The voices of the individuals who have participated appear in their original form. Text enclosed in quotation marks has been edited as little as possible to allow participants to authentically express themselves in their own words.

The project is ongoing and has no end in sight. Each new submission makes the work more meaningful, and the manifestation of each one is a collaborative effort. People from many countries around the world have contributed, and I would love for you to consider participating. You can do so by getting in touch with me at www.theluckarchive.org.

ACCESSION NUMBERING SYSTEM

LA.XX.Y.Z
LA = LUCK ARCHIVE
XX = YEAR OBJECT ACQUIRED
Y = OBJECT NUMBER
Z = PIECES IN SET IF APPLICABLE

THE LUCK ARCHIVE

One of the first things I did on my exploration was meet with a group of high school students to discuss their thoughts on luck. After talking about different definitions and interpretations of the concept, we wrote down the things we did related to luck.

Adrian

"Do not cut your nails on Sunday."

Rudy

"Do not walk under ladders."

Susan

"After studying quantum physics—cause and effect—for the last fifteen years, I have come to understand the direct correlation of the input-output of positive-negative beliefs and circumstances. I truly believe in universal balance, not luck."

Sonia

"Knock on wood."

Sierra

"I don't go to school on Friday the thirteenth."

Karina

"My parents light a green candle every night to a saint. They say it is for good luck and to avoid bad things. I've never seen that candle not lit at night."

Adriana

"Pick up your feet when you ride over railroad tracks."

Erica

"Pick a dandelion. Make a wish, and then blow to scatter the seeds with one breath."

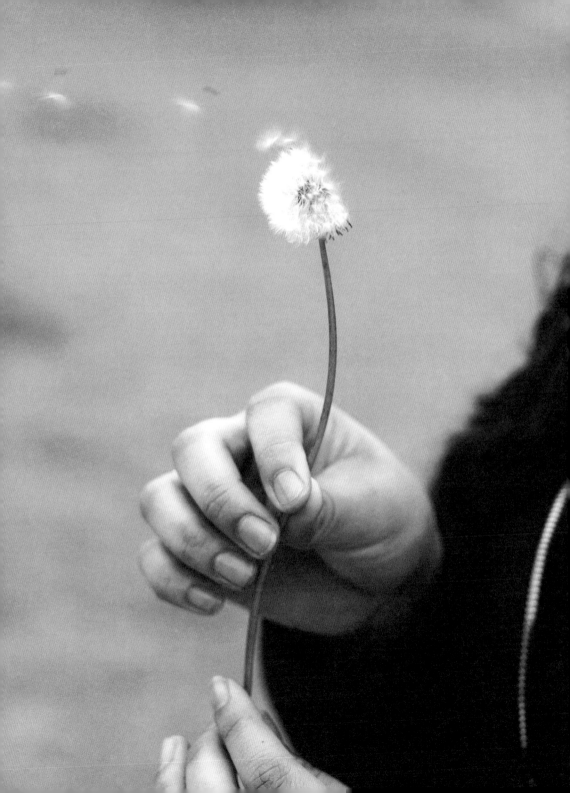

A few years ago I was thinking about starting the Lady Luck Challenge. I was going to invite people to break mirrors and stay in correspondence with me for seven years to see if it had a negative effect on their lives. But I didn't want to be someone who perpetuates bad luck in the world. I wanted to try and find ways to create new luck narratives for people, so I began leading four-leaf clover hunting trips. On the first trip Karina found a four-leaf clover after about twenty minutes. A few people on the trip were pretty skeptical about whether they really existed.

FOR:TVNA.
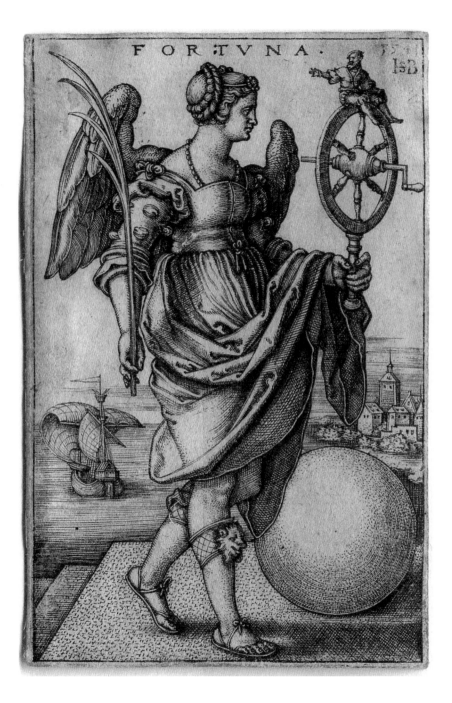

In Austin, Texas, I met a man on Craigslist named Allison, who goes by the name Cowboy. When we talked about luck, he quoted the golfer Gary Player as saying, "The more I practice, the luckier I get."

(OAK-9)OAKMONT,PA.,JUNE 17 — HAPPY HOLLER — Gary Player,who plays out of Ponte Vedra, Fla.,throws back his head and lets out a whoop of joy as he sinks a long putt on eighth hole for par on 3-par,253-yard hole in today's third round of the National Open Golf at Oakmont,Pa. Player made the turn with a two-under par 34 after starting the third round with a par,142 for the first 36 holes.(APWirephoto)(wra 7 1230 stf dm)1962

Jesse owns a gas station near my house. These are some of the things he has seen people do when they buy lotto tickets.

1. They see numbers on TV, in the news, etc., and play them.

2. Some people will not buy a certain number of scratch-offs.

3. Some want him to say good luck; others get mad if he says good luck.

4. Certain people make the sign of a cross over their tickets.

5. He has seen people put a picture of Jesus or the Virgin Mary on top of their tickets.

6. Some have their kids pick up the tickets from the counter.

7. He has seen people not buy tickets from certain cashiers or only buy from lucky cashiers.

8. Some people let the machine pick the numbers.

9. Some believe it's bad luck to put more than one number on a ticket.

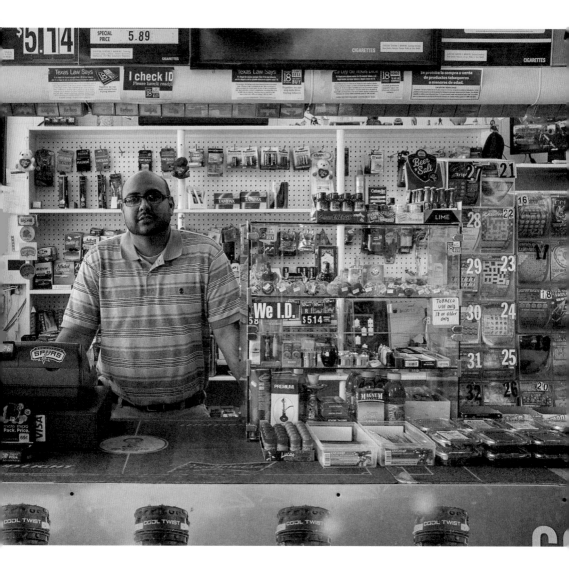

Bubba

"When you buy a lotto ticket you have got to believe 100 percent that it's a winner. If you have any doubt at all, you won't win. Some people drink beer. Some chase tail. Some buy dope. I play lotto."

LA.12.010

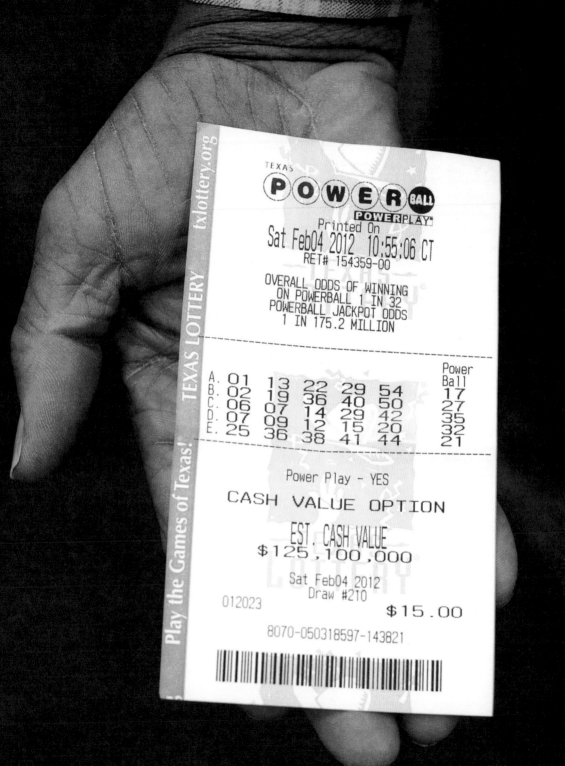

This photograph was taken at the exact moment Syler won a brand-new Toyota Prius at a Chicago Cubs game. Despite many of his family and friends constantly telling him that he is the luckiest person they know because of all the good things that happen to him, Syler does not believe in luck due to his religious convictions.

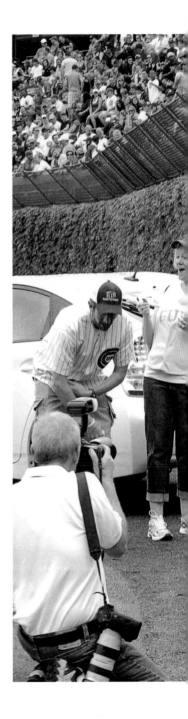

LA.12.011

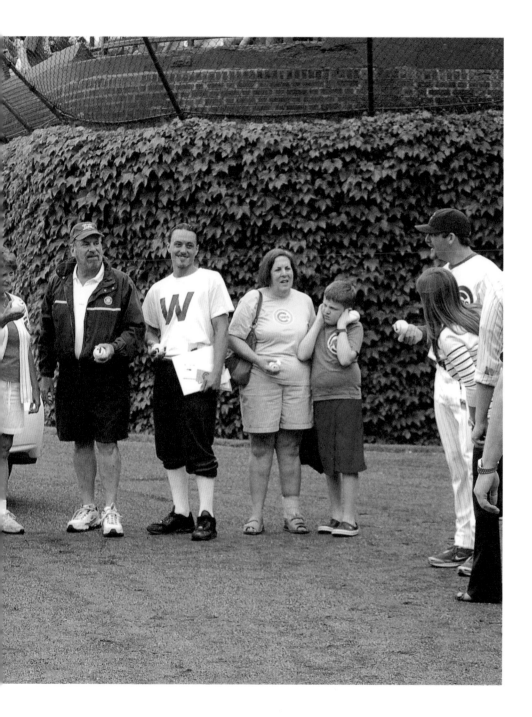

Rebecca

"I'm not really sure how I feel about luck, but I know I've gone through stages where I've thought it couldn't hurt to do something I thought would be lucky. One time that comes to mind was when I was much younger, probably around seven or so. My older, but not oldest, brother David played baseball, and he was a pitcher. Whenever an important pitch came up for him (its importance was determined by me), I would do what I suppose I thought was the best luck charm in the world: I would cross every part of my body I could. With my middle fingers over my pointer fingers and my ring fingers over my pinkies, I'd then wrap my arms around each other so my crossed-fingered hands somewhat crossed each other. Then I'd proceed to crossing my legs and then wrapping my right foot around my left ankle so there'd be an extra crossing. Finally I'd cross my eyes. I must have looked ridiculous, and it's not like every time I did it David threw a strike, but for whatever reason I felt it would help. I think I still did this when he was in high school, when I was as old as twelve or thirteen. I don't think I did it as often at these games, and maybe only during playoff games, but it was still there."

Lexa

"In April of 1994 I experienced my first panic attack. I was boarding a plane and may have noticed the pilot checking the engines. Once we took off I couldn't breathe or shut my eyes, or open them, or calm down. I was sure we were going to crash, because it all didn't make any sense—flying. I had to hyperventilate myself to sleep. I was given a small token from a friend: a blue stone, which my friend said I should use for luck while traveling. After that panic attack I reverted to Amtrak for a few years to travel across the country. Once I was ready to go back to Europe, I flew with that blue stone in my right pocket. The stone gave me luck. My planes didn't fall from the sky. Nor did any other planes. Maybe they wouldn't have anyway, but at the time it was thanks to that blue stone."

Zach

"In *The Old Man and the Sea* I read what seemed to me an appropriate definition of luck: a fluid, elusive force that could come right up to us and still go unnoticed. Luck is often a matter of perspective, and it seems to have this way of evading us too, because our circumstances and our wishes are also fluid."

The Old Man and the Sea

A NOVEL BY

ERNEST HEMINGWAY

THE
Scribner
Library

Alisa has to spit every time a black cat crosses her path to get rid of the bad luck. It doesn't matter where she is or who she's with. She has spit at business meetings, first dates, and many other places.

Bob

"It was a brisk night in the early 1970s. Riding a motorcycle, I passed a sign that read 'Free Kitten.' How fortunate; I was needing a cat. The animal, it turned out, had been a not-sought-after prize in a swim meet won by the young daughter of the house. The kitten was a tiny raven-black thing with wild fur and obsidian eyes that ascended the screen door to meet the person who finally wanted him, which I did immediately. At the risk of being shredded, I nested him into my coat, fired up the bike, and rode home. He purred the whole way.

"It was quickly apparent the kitten was something special—highly intelligent, eager, and loved people. He was my good fortune and needed a fortunate name. An artist friend of mine had just told me about voodoo charms, including a spell to do evil called a Jomo. However, the opposite spell, or its talisman, was a Mojo, invoked to do something good, which I had known from a Muddy Waters song. So he was Mojo.

"Mojo lived up to the name. Astonishingly athletic and personable, he took walks with me like a dog and would watch TV, preferring especially *Wild Kingdom*. He understood several words and phrases and often looked at me like he was about to speak. Cat haters who might visit left as newly minted cat lovers. He was a proficient hunter and always ate his kill, or most of it. I once found a gift on the back step, a squirrel tail attached to a squirrel anus. Moving to the country for a few years, Mojo's range of prey extended to include snakes, bats, and once, a grown rabbit. A large dark gelding on the ranch would come to the back fence for me to put Mojo on his back, something the cat loved as much as the horse.

"His veterinarian fell in love with him also, and when the awful day came and the vet told me 'we lost Mojo,' he wept."

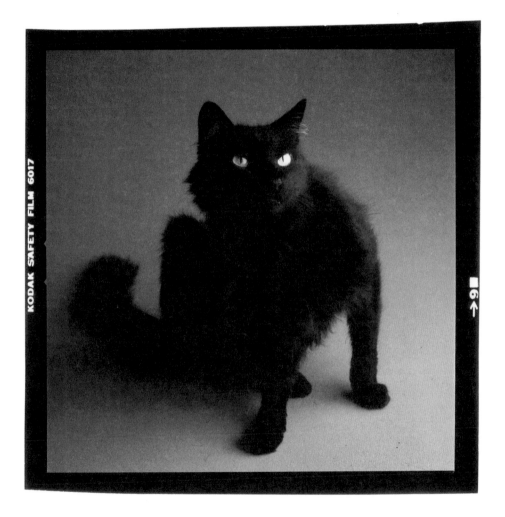

Amy hangs these ancient Chinese coins on the door of her restaurant to bring good luck and fortune to her customers.

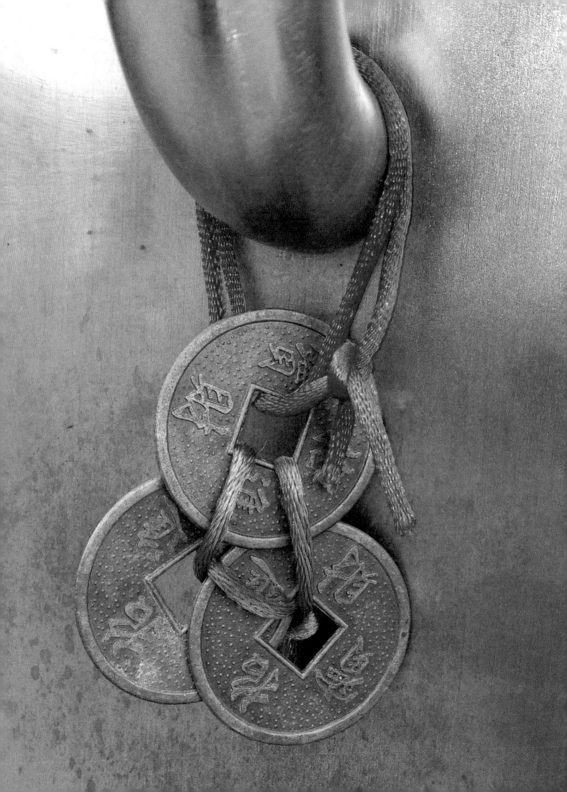

I met Sara at a coffee shop, and she told me that ever since she can remember, her family has been telling her she's lucky because she was born on St. Patrick's Day, 1986.

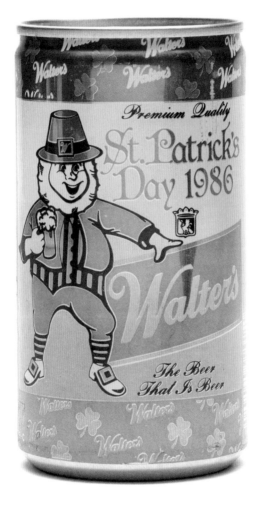

Jason

"Like many who play sports, I was superstitious about my approach to the game. It was only high school, I was okay but really just a scrub in the larger picture of the sport, but I still had a ritual of watching basketball movies before a game, eating Chinese food if at all possible, and most importantly putting a Reggie Miller basketball card in my sock before running out on the court. I wore the card in my sock throughout every game in high school, my way of having Reggie Miller impart some of his skill and wisdom to my game."

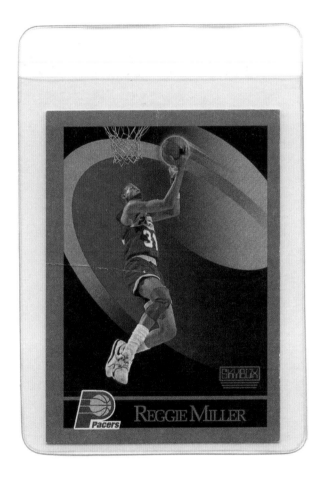

Julia

"My grandmother was a generous, fun-loving, kind, stylish, and eccentric woman who owned a lot of jewelry. So much that after she passed away we found unopened boxes of it with tags still attached. She purchased most of it on QVC, a shopping network she watched for several hours at a time. As a kid, I loved it because she would buy me presents like dolls and toys. The jewelry collection she had was very special to me. She kept it in boxes of all shapes and sizes and never hesitated to let me play in them. During visits with my grandma I would search the boxes and try on every ring, earring, necklace, and bracelet I could find. I loved the gemstones and thought everything was so beautiful. My favorite was the opal jewelry. My grandmother warned me that wearing too much opal or wearing opal not gifted to me was bad luck. I thought it was so strange that something so beautiful could be unlucky. Regardless, opal remained my favorite stone. I wore it all the time but definitely contemplated the bad luck I could create for myself by wearing it. This ring is from one of the jewelry boxes my grandma use to own. One small opal is balanced by several other stones, which saves it from being unlucky."

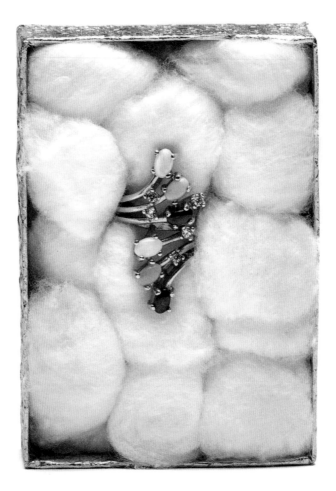

Aric is a motivational speaker and has spoken to thousands of young people across the country. Each time, he wears a pair of his lucky gray underwear. He estimates he has given over nine hundred talks in this pair alone.

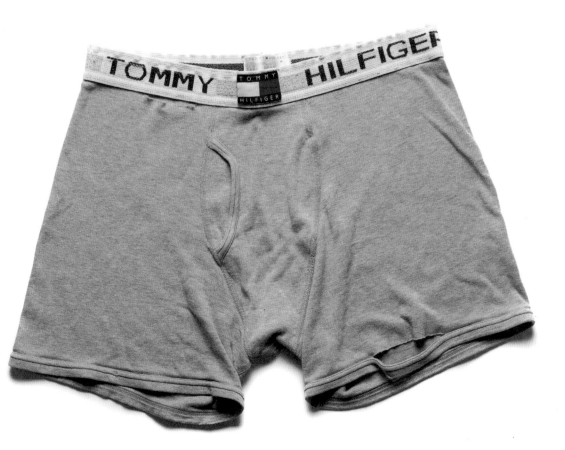

This small Buddhist statue was given to Milton during the Vietnam War. The man who gave it to him said that as long as he kept it with him he wouldn't die. He was wounded three times, but he did not die.

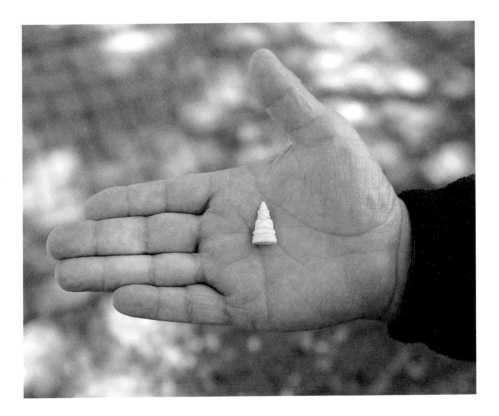

On November 11, 2011, at 11:11 a.m., I looked at my phone and saw this. I got so excited that I took a screenshot to share with my family and friends, but I forgot to make a wish.

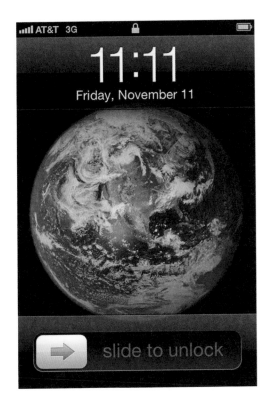

I stopped at a convenience store to purchase a beverage, and my change came to $11.11. I pointed it out to Tyler, the clerk, and he told me he did not believe in luck.

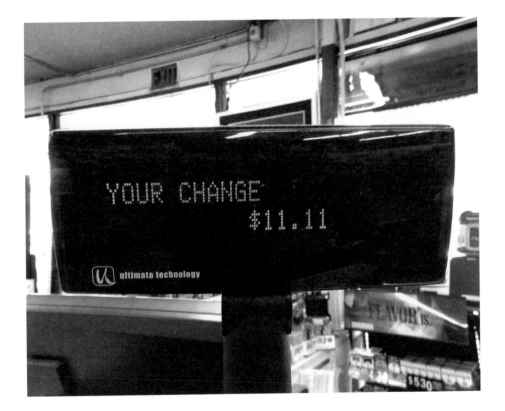

Katie purchased this whirling dervish evil-eye amulet at the Grand Bazaar in Istanbul, Turkey. She believes it protects her from evil.

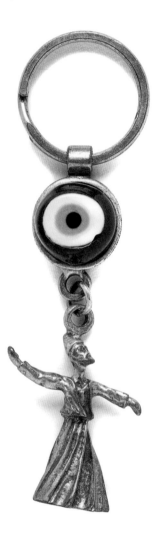

Alysha turns around two cigarettes as her "luckies" whenever she buys a pack.

Some people think that when you hang a horseshoe the ends should point up so the luck doesn't drain out. Others think the ends should point down so it falls on the person walking underneath.

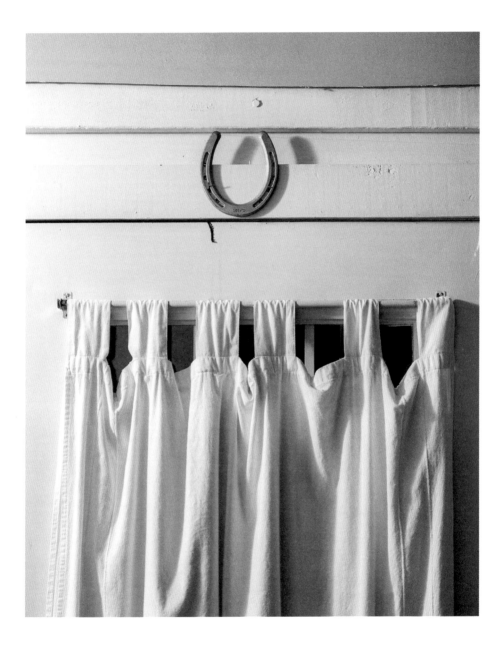

Chris and his mother have matching four-leaf clover tattoos on their necks as a symbol of their cultural heritage and as a way to bring them good luck.

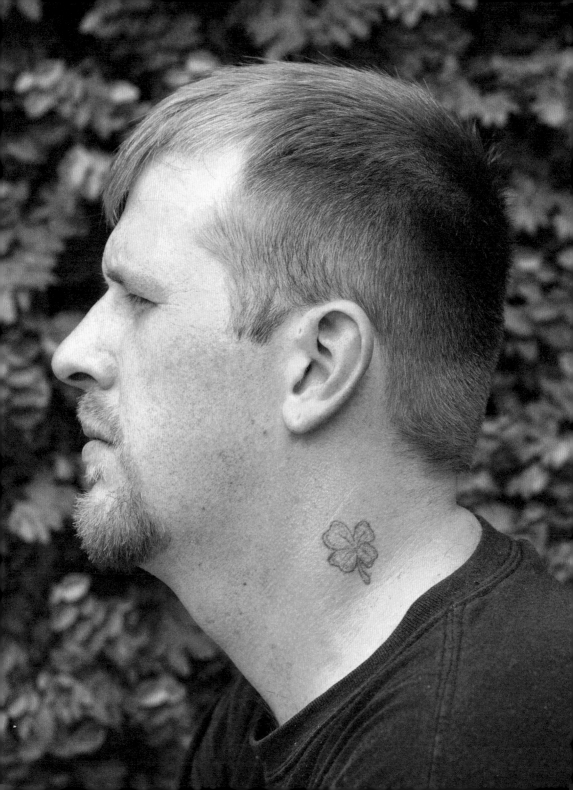

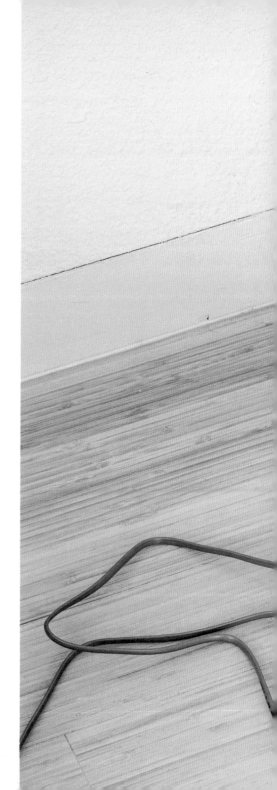

While I was eating dinner with a friend who is a chef, we began discussing the objects people carry with them for luck. The conversation eventually turned to rabbits, and my friend said he got them for his restaurant from Sebastian, a French guy with a small farm in the Texas Hill Country. I wanted to know what happened to all the rabbit feet, so I called Sebastian to schedule a visit. The day I arrived he was in the process of harvesting hundreds of rabbits for delivery. The feet, along with the fur and organs, were being burned in a small incinerator. Sebastian believes that you can always help luck along.

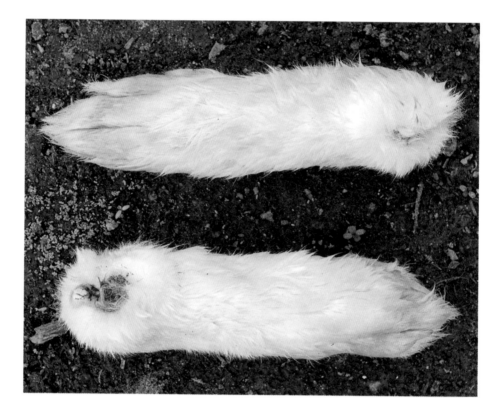

Marvin owns a rock shop outside of Austin, Texas. I stopped in to buy a small gift for my sons and came across this lucky quartz display. I offered to purchase the whole setup, but Marvin was unwilling to part with the basket and signs because the lucky quartz was his best-selling item.

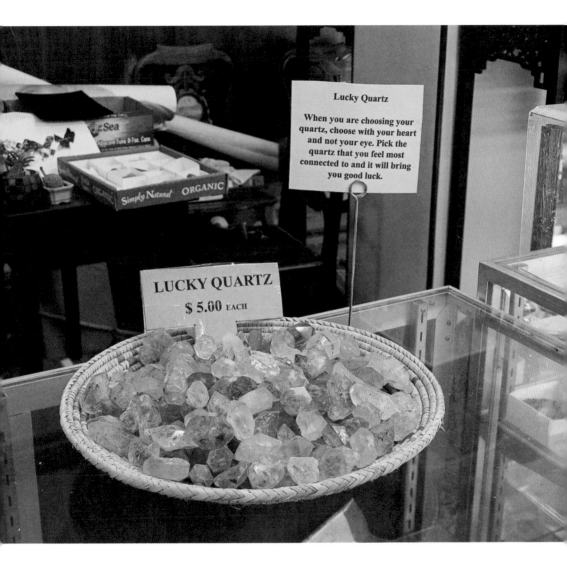

Lucky Quartz

When you are choosing your
quartz, choose with your heart
and not your eye. Pick the
quartz that you feel most
connected to and it will bring
you good luck.

LUCKY QUARTZ
$ 5.00 EACH

Simply Natural® ORGANIC

Michael has been in law enforcement for more than thirty-three years. He has been guarding this blue topaz inside a large museum for three of them. "Police work is more about instinct than luck," he says.

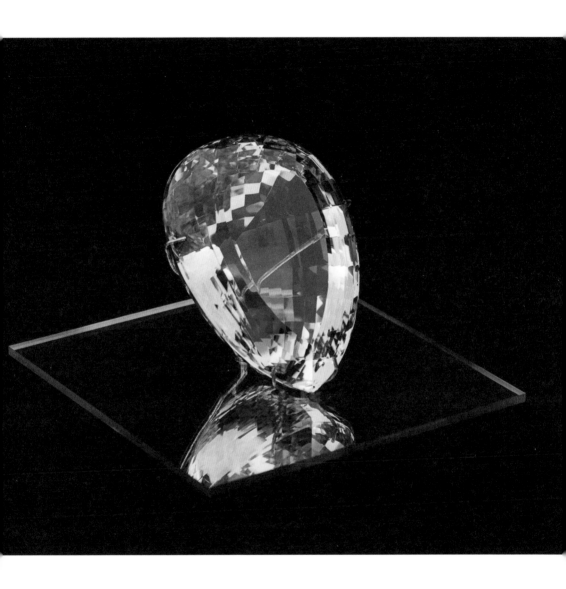

Despite the fact that Arion's mother found hundreds of four-leaf clovers during her life, she still had bad luck. She has since passed, and Arion is in the process of giving them all away.

Rekordössze

POZSONY,
PRÁGA
felé

BÉCS
felé

Parassapuszta

M15

Győr

Sopron

Tatabánya

BUDAPEST

M86

M1

...thely

M81

M0

Székesfehérvár

Veszprém

M8

Dunaújváros

Rábafüzes

K

Zalaegerszeg

LJUBJANA,
TRIESZT
felé

Lelle

M6

Nagykanizsa

M7

M70

Letenye

Kis

M9

ZÁGRÁB
felé

Kaposvár

Szekszárd

Szigetvár

Pécs

Mohács

Baja

Jennifer

"The jade is from China and was given to my mom over thirty years ago as a gift from her godmother. Shortly thereafter, my mom had the jade made into a ring by a jeweler in Taipei. It's a traditional Chinese three-legged money toad that is believed to attract wealth and prosperity and guard against bad luck. The third leg tucks under the toad's bottom so it doesn't poop out any of the luck it has been gathering. I wear the ring facing outward during the day so the toad can attract good luck and good fortune, and at the end of the day I turn the ring around so it can put the collected luck and fortune back into my system. I habitually pet the toad to encourage it to consume good luck, and if my day isn't going well I check to make sure the ring is facing the right direction. I consider myself a rational being, but I find comfort in my daily ring routine and knowing that my mom did the same thing for decades before she passed the ring on to me."

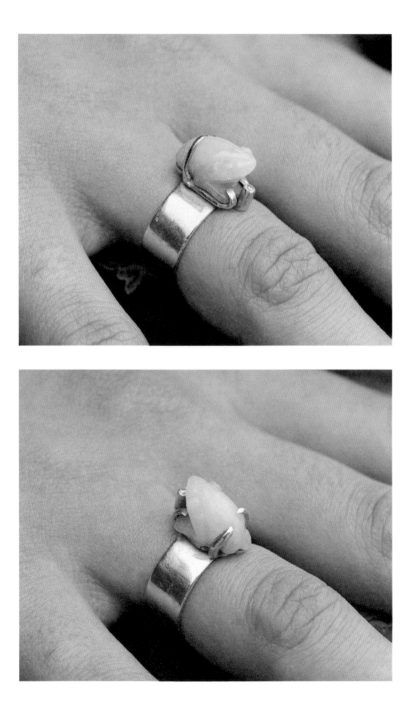

Paul grew up in a Christian fundamentalist home and was told that this was the definition of the phrase "good luck."

MAY LUCIFER BE GOOD TO YOU.

Hi, Mark.

Enclosed are some Patron Saint of Bicycling patches that I make. For me they very much tie into my ideas around luck, but I'm not a religious, and definitely not a Christian, person. I am, unfortunately, terribly superstitious though. I like to sew the prayers to the inside of clothes.

Be good.

Leslie

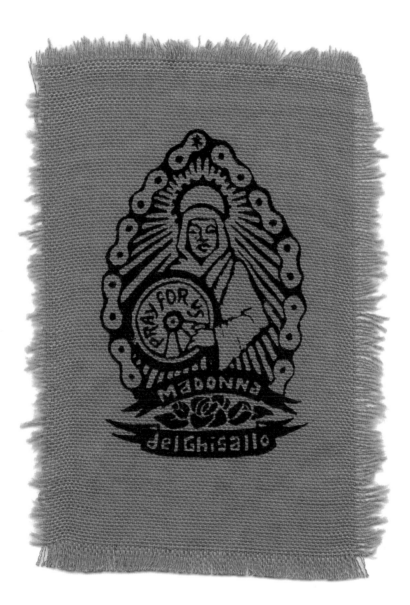

This photograph was taken by Lane in Santa Fe, New Mexico. She thinks it's really lucky to see a double rainbow.

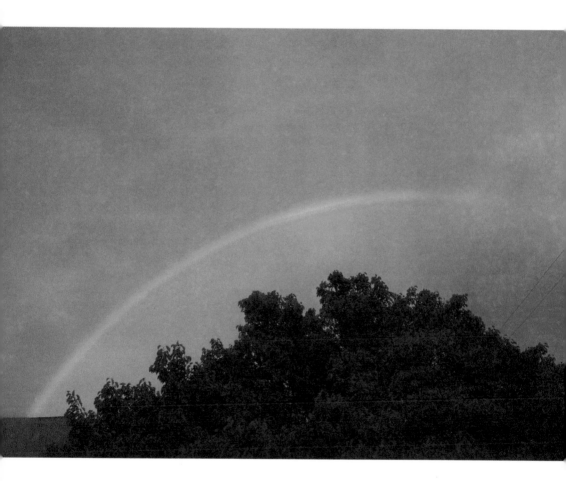

Thanksgiving Day

Jamie

"When I was a kid I was very superstitious. I believed in spirits and real magic, soothsaying, and jinxes. I've abandoned a lot of those ideas, but I still collect lucky pennies (only those found heads side up, of course). I keep them in an old coffee container with trinkets from my youth. Every so often I take them to a specific railroad crossing and lay them on the tracks to be flattened by the next train. The ones that survive this massive exchange of force and energy are given to people I meet who need a bit more luck in their lives."

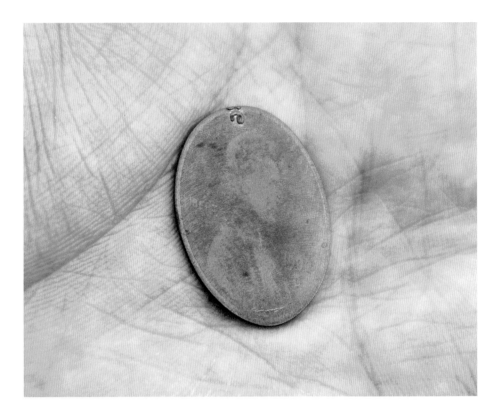

LuLu takes a stuffed peanut doll with her to play the slots at the casino. She sees lots of other people doing the same thing. She says it only works on the slots though.

Sally

"When I was in college I was in a sorority, and we had to dress up (like dress and heels) for the football games. It was semi-fun. And it semi-sucked! Regardless, I graduated and had little Alabama gear to wear on game days since I had been wearing dresses for four years each Saturday. I decided to buy a replica jersey of our hotshot running back and wore it all season. We went to the national championship that year and won (and the player whose jersey I wore became the first Alabama player to win the Heisman). So I bought a new jersey—the replica of the one they wore in the game with the bowl patch—and decided to wear it until we won another championship. Well, that happened to be the next year! So I bought another one. And that's how it started. I wore our championship jersey from the 2012 season all this year, but unfortunately we didn't make it to the big game. I'll continue to wear it until we win another national championship—and then I'll get a new one."

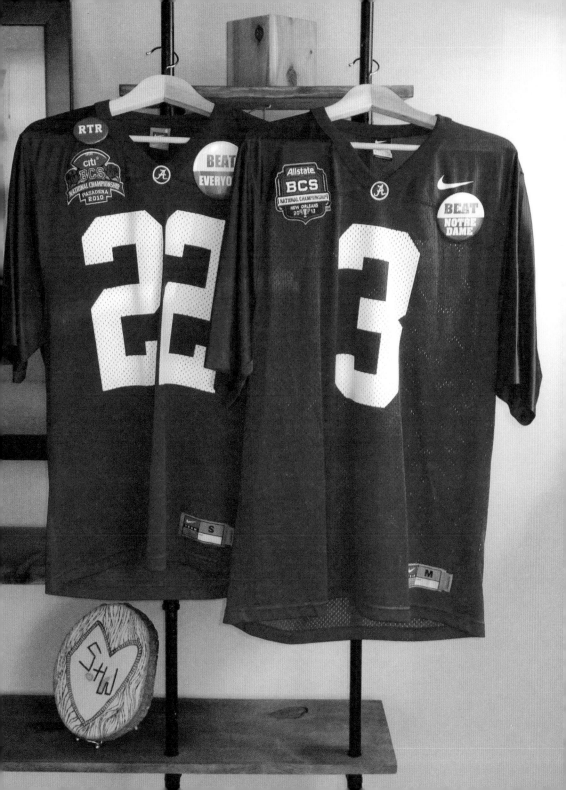

Jason

"The term 'QSL' means 'I confirm receipt of your transmission' for use in radio communication. During the height of citizens band radio popularity in the 1970s, more commonly referred to as CB, QSL cards were exchanged to signify contact between operators.

"I was drawn to QSL cards for their folk art quality and the stories they tell about the individuals who created them. As luck would have it, shortly after I discovered the QSL card scene I connected with a person in Canada who had the world's largest collection of CB QSL cards, and she sold me a box. I have an area in my studio that I have decorated with my favorite cards. They provide continual inspiration for my illustration work."

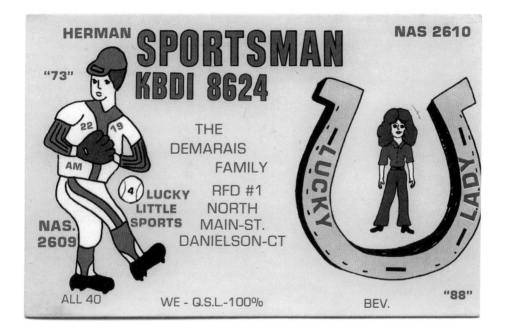

HERMAN **SPORTSMAN** NAS 2610

KBDI 8624

"73"

22 19

AM

4 LUCKY
LITTLE
SPORTS

THE
DEMARAIS
FAMILY
RFD #1
NORTH
MAIN-ST.
DANIELSON-CT

LUCKY LADY

NAS.
2609

ALL 40 WE - Q.S.L.-100% BEV. "88"

Station _____

This is to confirm our recent Citizen's Band
communication of 5/22, 19 79.

[] Nice talking to You.
[] Heard you on channel _____
[] Received your card from a friend.
[X] Received your Name from a friend.
[] Have your card and thanks.
[X] Please send card and thanks.
[] Please pass this card to a friend.

CJ KBDI 8624 3
Sportsman
532106

Printed by Cards, Inc. P. O. Drawer P, Lexington, N. C. 27292
FREE FULL COLOR QSL CATALOG WRITE TODAY

Post Card

PLACE
STAMP
HERE

This Side For Address

Please send Q.S.H. card
Thanks &
The best of luck to all
from our house to yous.

Bev & Herman

d532106

This fall I was at a wedding in Oklahoma City with my family. As we started our drive back to Texas, we stopped in Paul's Valley, Oklahoma, to gas up. When I got out of the car I saw a small gray kitten sitting on the gas hose. I knew my kids would want to take her home if they saw her, so I carefully moved her out of the way with my foot. After gassing up and using the restroom, we started home. As I was unpacking the car in our driveway, 417 miles later, I heard a meow from the engine compartment. The cat had climbed in and ridden the whole way back with us—through rain, cold, and three accidents on IH-35. I tried to give her away to a few friends, but each of them told me she was my cat. We decided to keep Pauli, and she became the Luck Archive mascot.

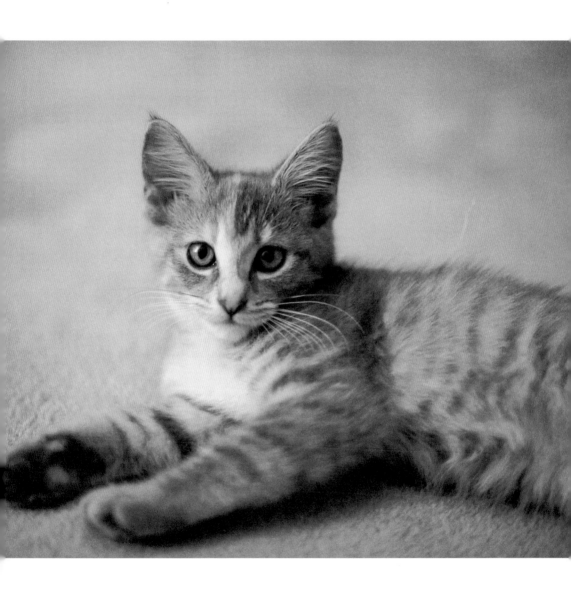

Piñatas are thought to have originated in China before the fourteenth century. In celebration of the coming planting season, they were filled with five types of seeds and hit with sticks of various colors. After they burst, the piñatas were burned and the ashes saved for good luck.

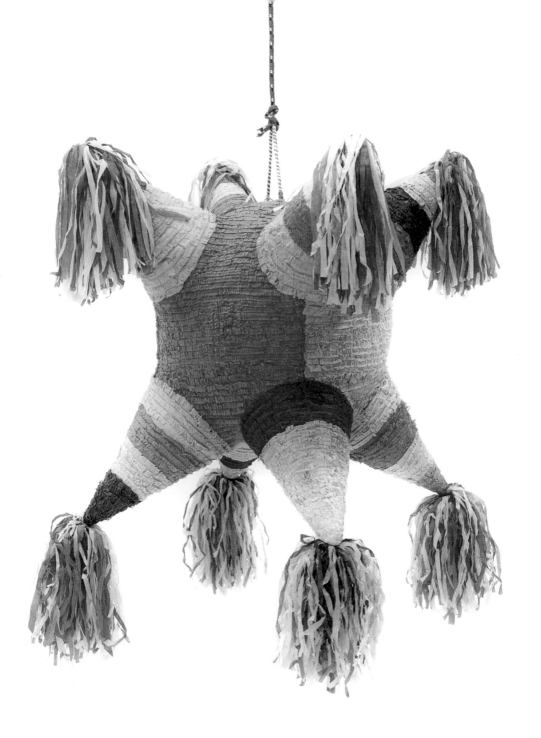

Border Patrol, U.S.-Mexico border,
Laredo, Texas

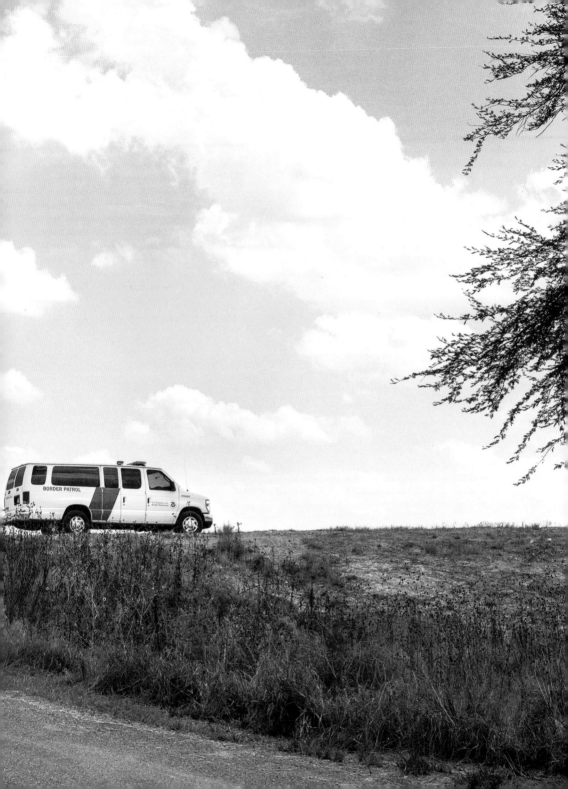

Longshot is a Marvel superhero whose powers include superhuman good luck that protects him when his intentions are pure. His left eye glows brightly when he uses his powers.

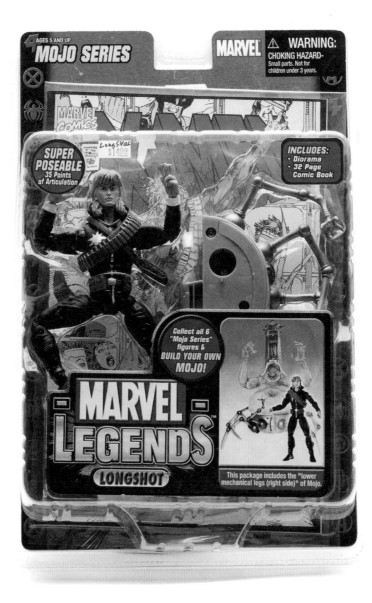

In the small village of Pomaire, Chile, it is believed that *chanchitos,* little pigs, bring good luck. Three-legged *chanchitos* are especially fortunate and are traditionally given to friends as a token of goodwill and love.

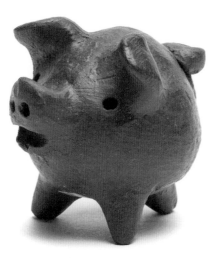

When I first exhibited the Luck Archive in Portland, Oregon, I invited people to send me pictures they took at exactly 11:11. Only a few people participated. One of them, Adam, continues to send me photographs a year later. To date he has sent more than sixty.

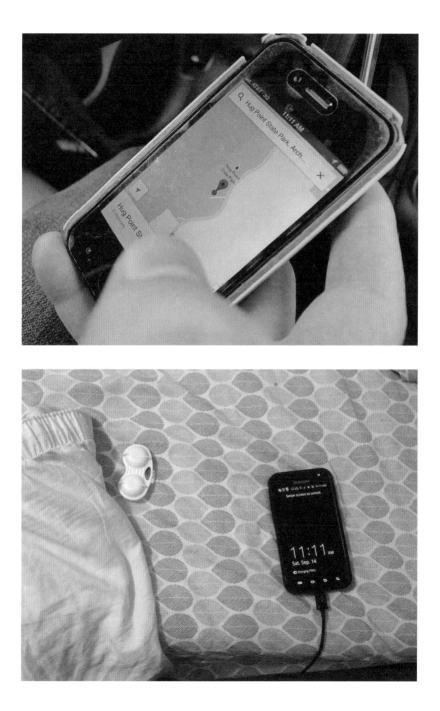

I bought this High John the Conqueror root from Lady Mimi, a witch in the French Quarter of New Orleans. She told me this was the thing that would bring me the most luck or, as she put it, mojo. She said to carry it with me and blow smoke on it, pour alcohol on it, and even rub it with bodily fluids. All of this would make it more potent.

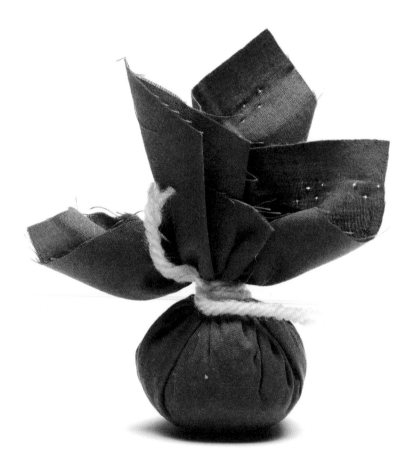

LA.13.062.1–3

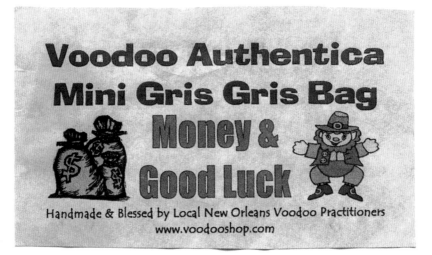

Voodoo Authentica
Mini Gris Gris Bag
Money & Good Luck

Handmade & Blessed by Local New Orleans Voodoo Practitioners
www.voodooshop.com

Instructions.

Hold your bag and focus on the specific need or desire you have. Use "creative visualization" – in your mind, see yourself accomplishing the goal. Picture yourself buying the car you want, doing activities with the type of love you seek, getting that promotion - you get the idea! Do these acts of meditation as often as possible - this empowers your bag to work for your purpose. Keep the energized bag with you always. Carry it on your power side - that's on the left for girls and on the right for guys. We wish you many blessings in your magickal pursuits!

"I use the term 'luck' to designate what the Greeks designated by *tuché,* namely, events over which human agents lack control; it does not connote randomness, or indeed any particular view about causality."

MARTHA C. NUSSBAUM

The Fragility of Goodness

LUCK AND ETHICS IN GREEK TRAGEDY AND PHILOSOPHY

UPDATED EDITION

WABISTORY

My friend Ben started a project called wabiStory where he invites artists and authors to leave digital recordings in public places so people can access them through their digital devices. He invited me to participate, and I decided to go to every place listed in the San Antonio phone book that had the word "Luck" or "Lucky" in the name and participate in whatever service the business offered. There were thirteen places listed. I got my hair cut by a barber who sailed under a double rainbow while on a cruise in the Bahamas. I watched game 6 of the NBA finals at the Lucky Monkey. I bought lottery tickets utilizing various strategies I had learned over the course of this project. Tried on jeans, toured manicured landscapes, sent my wife to get her nails done, and even had my face read by a medium. To end it all, a group of us got together and played bingo at the Lucky Ballroom. None of us won.

Lucky Ballroom & Bingo

Lucky Nails

Lucky Village

Mr. Lucky's Tattoo

Lucky Lawn Service

Lucky Store

Lucky 7 Food Mart

Lucky Brand Jeans

Lucky Liquors

Lucky's Food Mart

Lucky Monkey Sports Bar

Lucky Burger

Lucky Star Barbershop

MISSIONS

My father-in-law mentioned one night that of all athletes, baseball players
were the most superstitious. I decided to approach the San Antonio Missions,
my local minor league baseball team, about exploring luck, superstition, and
tradition with them. They were open to the idea but thought I was a bit strange.
During my time with the team I talked with players, former players, front
office personnel, major league scouts, and sportswriters. Eighteen people in the
Missions front office had been growing "playoff beards" since the beginning of
August. They said they wouldn't shave them off until they won the championship
or were eliminated from the playoffs. The Missions won the Texas League title
for the thirteenth time in September 2013 when Johan Limonta hit a grand
slam in game 5.

Lee Orr has had the same batting ritual for five years. His approach song is "It'z Just What We Do" by the country music duo Florida Georgia Line. If it doesn't feel right when he steps up to the plate, he calls for time and steps out of the box:

Wash out dirt right. Wash out dirt left. Kick dirt toward pitcher. Tap right foot, Tap left foot. One swing. Tap corner of box. Half-step right foot. Look at bat. Say "See it up." Deep breath. Half-step left foot. Half-step right foot. Half-step left foot. Dig in.

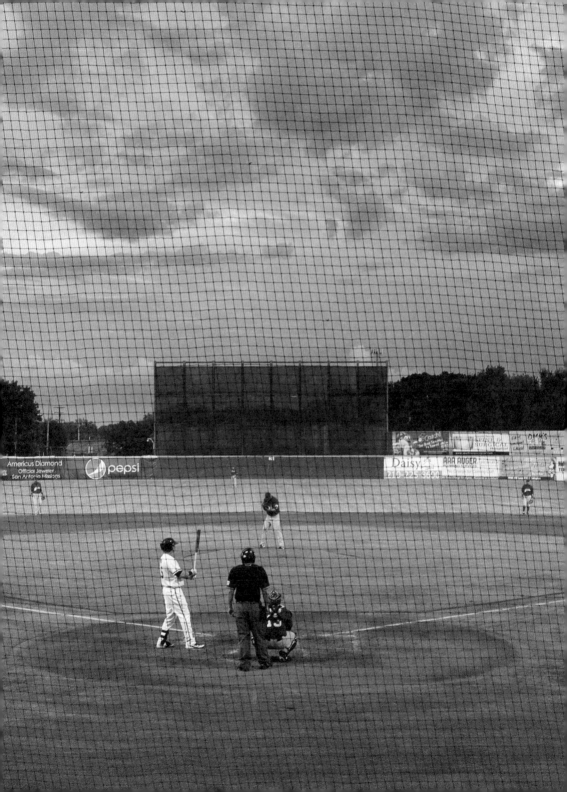

Mickey

"The first thing to know about luck in baseball is don't talk about luck. It may upset the baseball gods."

Jeff

"I think there is such a focus on superstition and ritual in baseball due to the pace of the game."

Brian

"Never touch another player's glove."

Joe

"When some guys are on a bad streak, they'll do everything they are not supposed to do in order to change their luck."

In the first inning of the game, Tommy Medica #7 came to bat. I wondered if something good would happen to him because of his jersey number. He got hit by the next pitch and advanced to first base.

LA.13.083

LA.13.084

LA.13.085

LA.13.086

LA.13.088

Steven and Julie Ann

"Repeated sightings of 11:11 have happened to millions of people throughout the world. Many are wondering why this is happening. They wish to know, what does their constant seeing of 11:11 signify? It's almost like getting a regular 'nudge' to look at the clock, a receipt, or odometer at precisely the right moment, usually when focused on something else.

"Basically, seeing 11:11 is a trigger point of awareness, an 'awakening code.' You are starting to awaken to your fullest potential of who you really are. There's a stirring deep inside, as a hint of remembrance of something long forgotten. It's time now to take a good look around you and see what is real and what is illusory. It is time to pierce the veils of illusion, which have kept us bound to an unreal world. The revealing or revelation most likely will occur in stages that may be uncomfortable and unsettling at first, yet you will yearn to explore deeper and fuller. Where the search takes you will be up to you, and will depend on your unique path, so follow your intuition and your JOY and the information will appear at the right time. You are transitioning to a point of exciting discovery in this duality game and opening up to the possibilities of universal exploration. Here are some questions to begin with: Are we all interconnected? What is Oneness? Be open . . . it will be a magical journey if you allow it."

EXPIRATION	
DATE	TIME

09/12/13 11:11 AM

09:11 AM $ 3.00 121046
PAID

PARKEON

LUCKY 13 TATTOO

When I was visiting businesses with the word "Lucky" in their name, I met Steve at Mr. Lucky's Tattoo. He told me that every Friday the 13th the shop offered Lucky 13 tattoos for $13 plus a mandatory $7 tip. I asked if he would consider designing an official tattoo for the Luck Archive. On September 13, 2013, nine of us got the tattoo.

LA.13.090

LA.13.091

LA.13.092.1–4

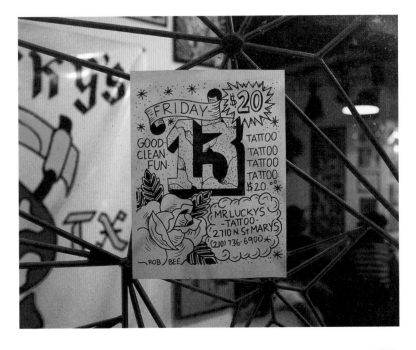

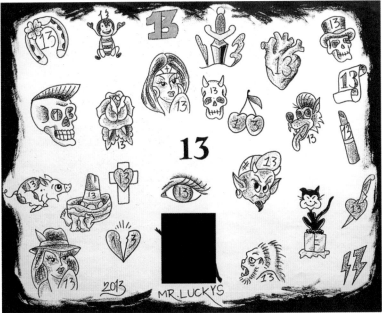

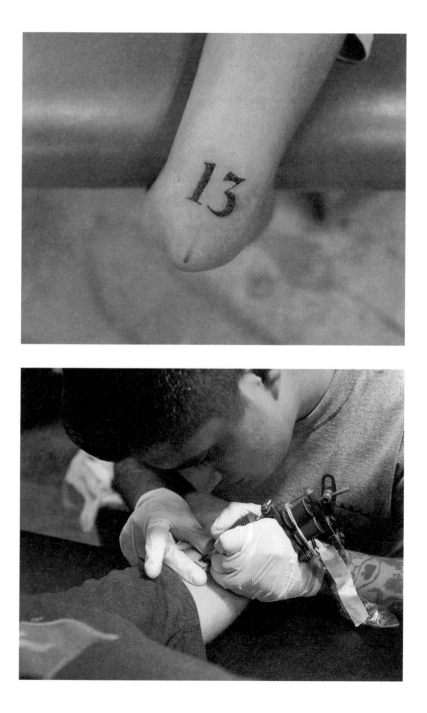

SUPER G EXPERIENTIAL RESIDENCY PROGRAM

As part of an experiential residency inside the Super G Mart, an international grocery store and flea market in Greensboro, North Carolina, I decided to purchase every item that used the concept of luck or fortune in its marketing– seventy-three objects in all. Working with the flea market vendors, I created an installation that was open to the public during regular operating hours. If someone wanted to purchase an item, I directed them to the original vendor. All of the items were photographed at Two Chicks Photography, a family-owned studio located inside the grocery store.

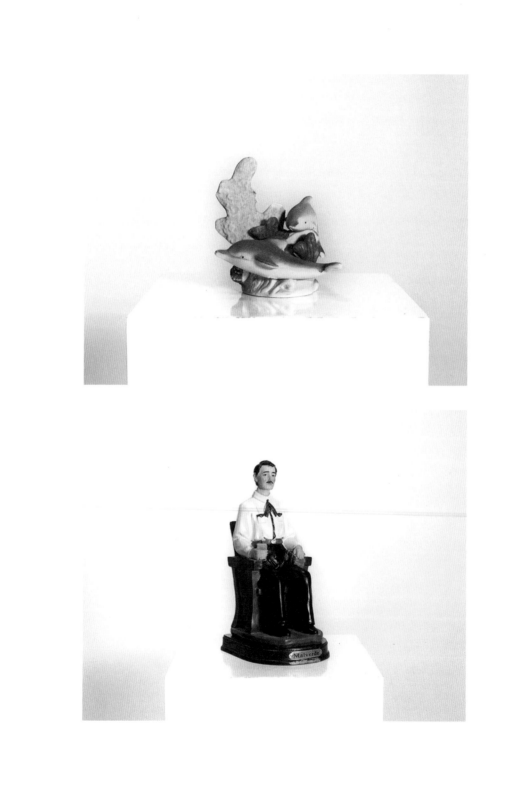

DAD

YOU'RE THE GREATEST DAD
IN ALL THE WORLD.
WISE, LOVING AND TRUE.
I'VE BEEN SO LUCKY
ALL MY LIFE
TO HAVE A DAD LIKE YOU.

Noh and I were discussing the items she sells in her store to bring good luck—
frog statues, dragon bamboo vases, coins, waving cats, and so on—and when we
were done, she said, "But Jesus is the luckiest."

The Snack Lady

"I saw this quote on Facebook and liked it."

MESS
WITH ME
KARMA
WILL GET YOU
MESS WITH MY FAMILY
I BECOME
KARMA

Jane

"I was seven years old. I went to spend the summer with my grandparents. My cousin Elaine, she was ten, and my other cousin Sissy, she was eight. About the third week I was there Elaine brought out this Ouija board while my grandparents were asleep. I didn't know what it was. She told me to put my fingers on the little squares and not to press down. Sissy was on the right side; Elaine was on the left. So I did that, and she asked it some questions. It moved. Freaked me out. Scared to death. So I jumped off it. She told me to put it back on there. I was the youngest one so I felt like I had to do it. I just wanted to get off the game. The next day we go outside to play, and I fall off the playhouse and sprain my ankle. Two weeks later I fell off again and broke my arm. To me, that's when my bad luck started. It has continued ever since."

In 2004 a couple of friends called Zeke and told him to come over to their house. When he drove up, they gave him $5,000 and said to keep driving. If he had known his friends had done something bad, he wouldn't have gone with them. They ended up snitching him out. He told the judge his story and got a lean sentence. Six months. What Zeke didn't realize at the time was how being a convicted felon would affect his life. He said it was lucky that he got a short sentence but unlucky that he's now a registered felon. He hasn't been in trouble since. Not even a traffic ticket.

Michelle

"Let me tell you the whole process of lottery. I only play Lucky Loot, and when I go in, the roll has to be halfway done before I buy any cards, because I feel all the money is in the middle. When I buy the ones at the beginning, it's nothing. It's like $2. I never get anything at the beginning of a fresh roll. When I come in, people be like, why you looking around the corner. I say, I'm measuring something. I look to the left, I look to the right. If the roll looks thick, it means there's nothing. Don't touch it. If it's thin, that means there's money. I get those.

"I go home. Put them to the side. Let them marinate a little bit. Get comfortable. Make sure everything is just right. Take a bath. Fix me something to eat. Get everything out of the way so nobody won't be saying, Michelle come here. Because I feel like if they call me, it throws off my luck and my attention to my cards when I'm scratching. Once everything is quiet I find my lucky penny. If I can't find it, I will go to the extreme to find it instead of finding another penny. I scratch off one card at a time. I don't go fast. I scratch about one every hour. If I'm rushing it feels like I'm throwing my luck away. If I take my time it'll surprise me. And that's what happens. That's when I get the $150 each week. I buy the cards from different stores. I have a colored pen that I mark on a map which store I get them from. A lot of the winning cards are from stores that are farther out. Not just from my side of town. I mark how many times I win from each store. One store I win from all the time now is right around the corner from here. I constantly get $100 from him."

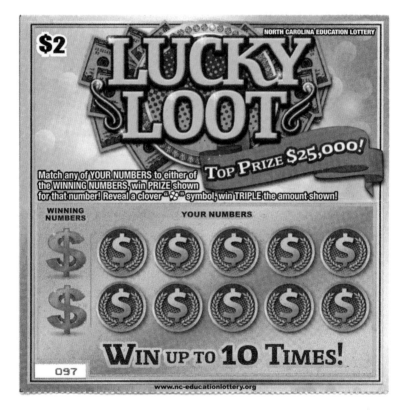

Tony custom-made these scents for the Luck Archive. "I started off selling drugs. Then jeans. Pocketbooks. And now scents. Been selling them for ten years," he said.

Sarah

"I spent most of my midtwenties trying to become financially stable so I could afford a dog. My family always rented houses growing up and we were never allowed to have pets. I finally landed a stable job when I was twenty-six and adopted a small black dog from the local shelter. After observing him for a weekend, I named him Lil' Romeo because of his love for women. A friend mentioned that the name Romeo was unlucky given how Shakespeare's Romeo met death at such an early age. Within a year Romeo started developing hip and knee problems. I took him to an Episcopal church to have him blessed in the spring. I never changed Romeo's collar or cut his hair after he was blessed in hopes that his health would improve. I felt since the water they used during the blessing was special, the collar was lucky and it would somehow help extend his life. Unfortunately, by age two, Romeo was unable to process his food and the vet said his time was up, that I had picked a lemon of a dog. After Romeo died, I kept his lucky blessed collar for seven years."

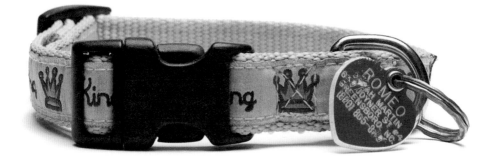

Rachel

"I learned of the Daruma doll, a Japanese symbol of perseverance and good luck, in a text that I recently read during my graduate studies. I like the intentionality behind the tradition of placing a mark on a single eye of the doll regarding a specific dream, idea, desire, or hope, with a firm belief that it will come to pass. When the moment of fulfillment has arrived, a second dot is painted on the remaining blank eye. I am intrigued by the thought that completion of a particular task or goal brings balance into one's life and new insight into the world. There seems to be an embodiment of beauty and achievement as this ancient symbolic doll looks back at me with a wide-open gaze, a reflection of what one can indeed accomplish inside of all being."

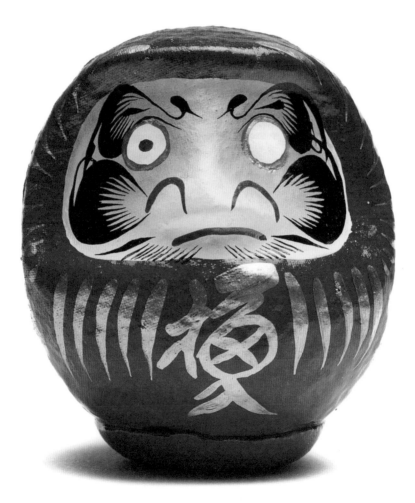

Hotei, god of abundance and good health

Jurojin, god of long life

Fukurokuju, god of happiness, wealth, and longevity

Bishamon, god of warriors

Benten, goddess of knowledge, art, and beauty, especially music

Daikoku, god of wealth, commerce, and trade

Ebisu, god of fishers or merchants

THE SEVEN LUCKY GODS OF JAPAN

by Reiko Chiba

七福神

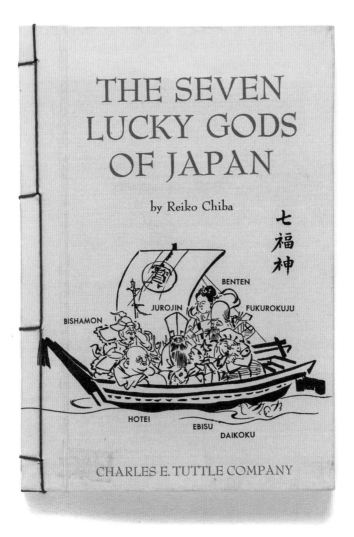

BENTEN

JUROJIN

FUKUROKUJU

BISHAMON

HOTEI

EBISU

DAIKOKU

CHARLES E. TUTTLE COMPANY

On New Year's Eve my wife and I went to a party, and over casual conversation Patricia mentioned that she had brought grapes so we could bring in the New Year properly. A bit puzzled, I asked her to explain. She told me that in many Latin American countries it is believed to be good luck if you eat twelve grapes at midnight of the new year, one for each month.

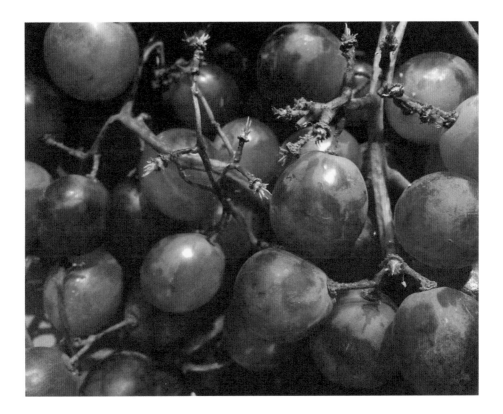

BOTÁNICAS

Botánicas are stores often found in Latino communities that sell religious candles, amulets, plants, oils, and other objects commonly used in folk religions. I wanted to learn about specific things the vendors did or sold that related to luck, so I collected objects in several shops in California and Texas.

LA.14.110.2

LA.14.110.4

LA.14.110.6

LA.14.110.8

LA.14.111.1

LA.14.111.3

LA.14.113.1

LA.14.113.4

LA.14.114.2

LA.14.114.3

El Chief Special Brown Oil

Doble suerte rápida

Garlic clove

Rose of Jericho

Road opener fixed candle

Santa Muerte wall hanging

Peruvian bone amulet

Indian amulet

Peruvian charm vial

Horseshoe prayer

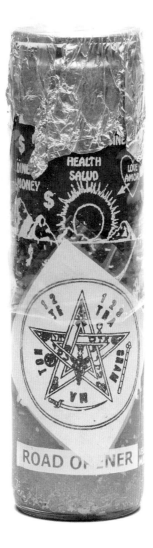

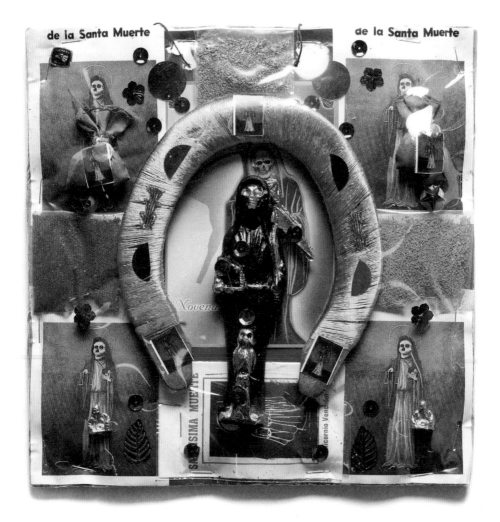

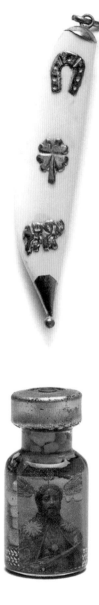

WHO EVER CARRIES THIS THING WILL HAVE GOOD LOCK ON LAND AND SEA

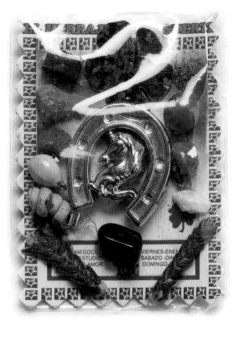

Jorge, son of Chango, according to Santería

"The correct way to use the bath of twenty-one plants is after your normal shower, mix the bottle with a gallon of warm water. Pour it over your body little by little. When you are doing this, pray the Our Father. When you are done, let it soak into your body for ten to fifteen minutes. This is so the bath will be absorbed into your body. It will change your aura and give you more luck. And after that, you come back to see us."

DOLORES PARK

For many years I worked as a social worker doing direct outreach on streets in the United States and South America. I decided to do something similar, but this time I would try to talk with people about luck. I was heading to San Francisco and decided to start there. I spent over four hours in Dolores Park and handed out 207 flyers. Most people politely took one. Others understandably said no thanks. I talked with over a dozen people, though, and even got a call from a man a month later.

�֍�֍✖✖✖✖✖✖✖✖✖✖✖✖✖✖✖✖✖✖✖

I WANT TO SPEAK TO YOU ABOUT LUCK.

About the ways it intersects with belief,
culture, superstition and tradition in your
life. Things you do for Good Luck or to
avoid Bad Luck. Ways you use the word
Luck to describe or make sense of
what has happened to you.

I have been talking to people about this for
the past two years. With your permission,
our conversation will be collected into an
ongoing artistic project titled,
The Luck Archive.

I would love to speak with you today if you
are interested. You can also call me at
210-241-7364.

Thank you for your time.

Mark Menjivar

DELIVERED JAN 0 9 2014

Bianca

"Most people believe luck rests in the belief of religion or culture, but clearly luck is all about action. If one uses good luck in their lives he or she can be considered lucky. Acting out luck will sure bring in luck. Scientific studies have shown that people create their own good or bad luck. Lucky people generate their own good fortune. I have learned that creating good luck takes great skill."

She walked by and took a flyer. Thirty minutes later she came by again and told me that she and her sister had gotten matching owl tattoos for good luck. I forgot to ask her name.

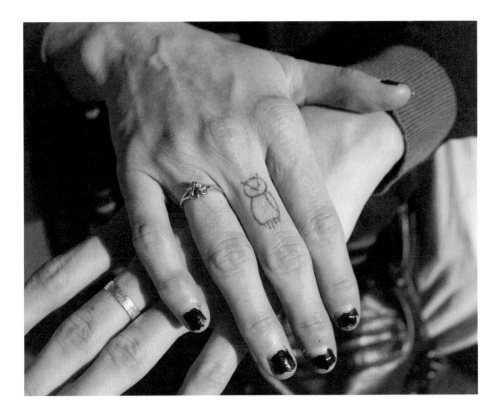

Denzel has been skating since he was a young kid. Whenever he is about to attempt a difficult trick he taps his right thigh three times.

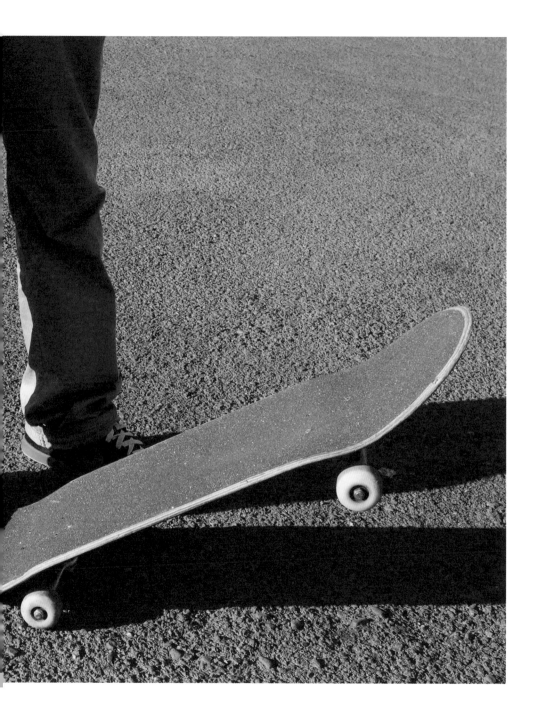

Matt recalled that as a child he would often go through a big tunnel in Malibu Canyon when he was on his way to surf. As he went through the tunnel he held his breath and made a wish. The day after I talked with him I was driving along the coast and saw a tunnel up ahead. I successfully held my breath and made a wish.

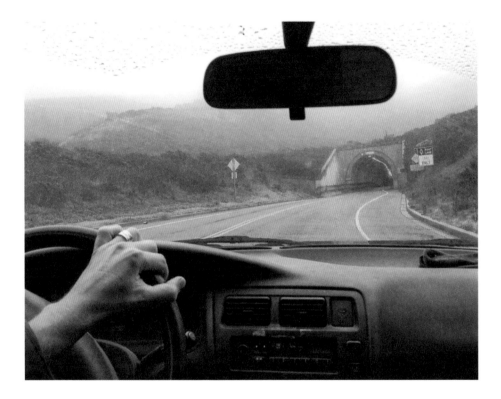

Angela

"From a very young age I was taught that birds can't be in or on anything in the house. Or on your clothes. Or your sheets, your jewelry, your lampshades, your carpet. My great grandmother came from Ireland, and I guess this was what was passed on in my ancestry. Fear of birds morphed into fear of birds in the house. I mean, sure, a caged bird has its metaphors, and free as a bird implies that birds aren't supposed to really be indoors. Or pets. I did own a sweater once with the old sailor swallows encrusted on the pectoral muscle area, but I gave it away. Dang, I loved that kitschy pearly pink rockabilly sweater. But it had birds on it. It had to be passed on.

"I've thought about specific birds. I mean, there's the crow or raven and its ominous symbolic dark and doom and death wings. I would die if one came in my house! And the robin? It doesn't matter, I would die from him too, or someone else might. I can look at birds outside, or even in a zoo. I mean, I am super into the *Portlandia* bird thing. If only I could join in the fun. Or get a super cool peacock tattoo. I've thought about owls. And how they might mean something different. They're birds, but they eat meat and they're super nocturnal and godly. Maybe they might bring me luck instead of bad luck? No. I would die if one came in my house. Or someone I know would."

Eliza

"When I was growing up, my dad told me that if I said the words 'Rabbit, Rabbit!' before I said anything else (anything AT ALL) on the first day of the month, I'd have good luck all month. He also has us jump into the New Year every year for luck–at 11:59 everyone has to climb up on the nearest sofa, couch, stair, ottoman, whatever, and at the stroke of midnight we all leap off."

rabbit

rabbit rabbit

The gift of an eagle feather is considered good luck for both the giver and the receiver. Illegal possession of one can bring a fine of up to $10,000.

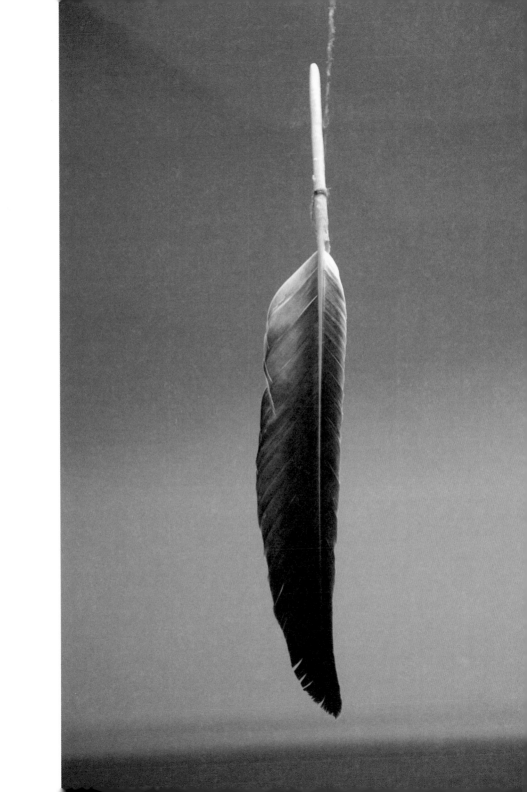

Nolan

"On a particularly important walk early in our relationship, Nina and I found two of these walnut shells at the base of an old tree on our farm. We now carry them in the pockets of our jackets. For me, when I put my hand in my pocket, I am reminded of how lucky we are to have met each other."

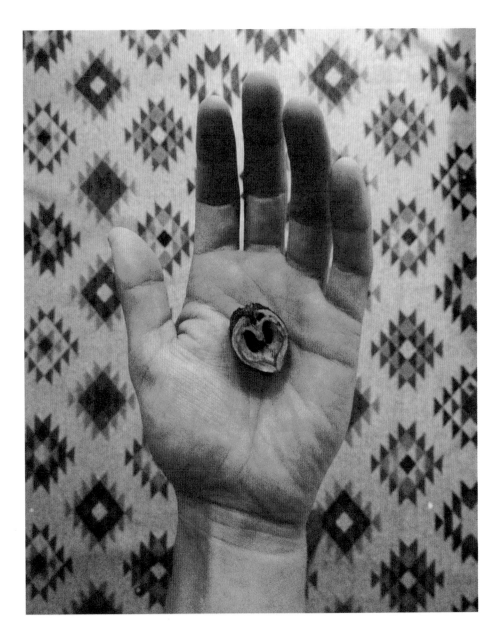

I met a woman in North Carolina who
believed Lincoln wheat pennies were lucky.
If she found one she would carry it in her
front pocket. I started to look for them.
But after weeks I still had not found any,
so I decided to order five hundred online
and distribute them back into the monetary
system. To do this, I walked around
downtown Portland, Oregon, dropping
pennies at random. If anyone approached
me or if I saw anyone asking for help, I asked
them to help me. Maggie, Brittney, Aaron,
Chuck, Tom (who used to collect wheat
pennies as a kid), Kevin, Samson, and April
assisted in the redistribution process.

LA.14.132.1–9

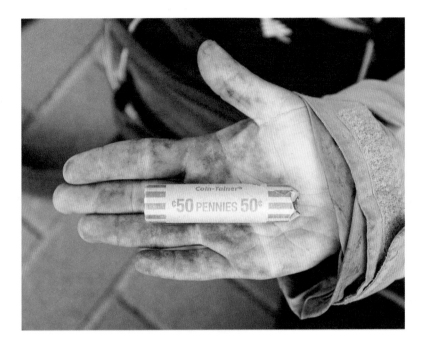

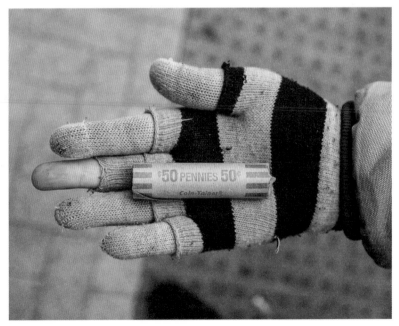

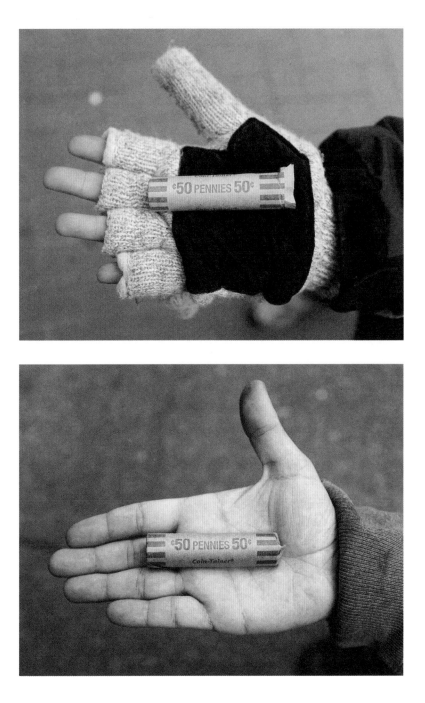

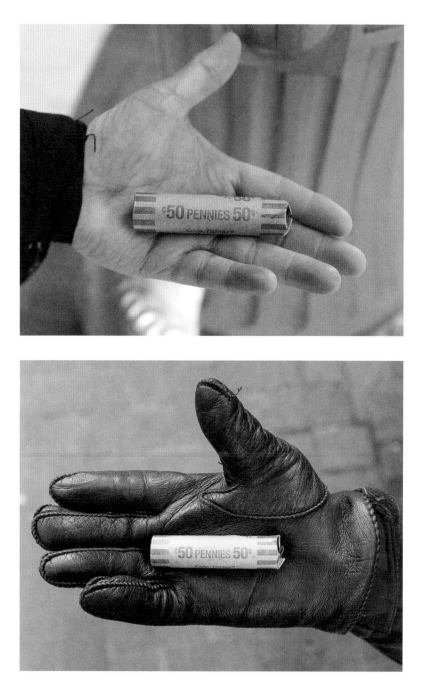

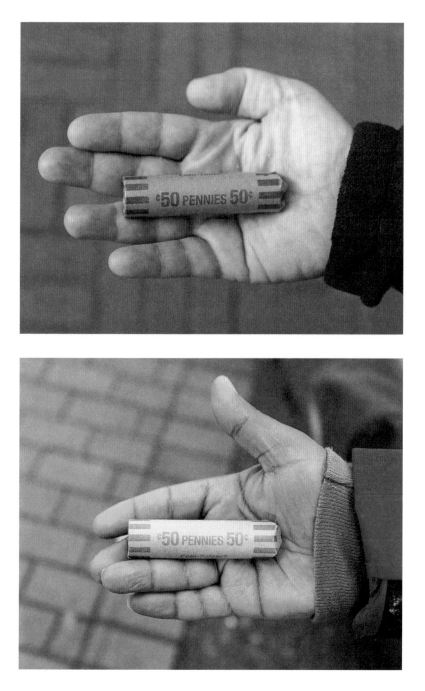

Nicolette

"For much of my life, I've felt luck the way a person with a bad knee might feel a rainstorm coming. I can tell when I'm in luck's path, and if I'm not in it I'll make adjustments to my thought process or emotions in hopes of jumping on board. As a singer/songwriter, that kind of self-correction seems to come up most when I'm performing music, prepping to go on stage, but it could happen any time I feel pressure for things to go my way. Good luck just seems to have a feeling, and if I hold the antenna just right I can dial it in. If all of that sounds extremely inexact, that's because it is. Which is why I have found myself drawn to a writer named Rob Brezsny who puts out a weekly astrology newsletter—one I've gotten in my email box for many, many years. His writing style celebrates paradox, relishes in metaphors, and generally occupies that gray area between fact and feeling. His weekly horoscopes always uplift me, and I wait for them eagerly, hoping to catch a glimpse of how I can better feel my way through the dark toward success, happiness, good luck. I don't claim to have the right or only answer about luck; I just know it works for me. For me, luck is a belief system. If you believe it's coming your way, it is. If you don't, it's not."

Leprechaun carnival cutout

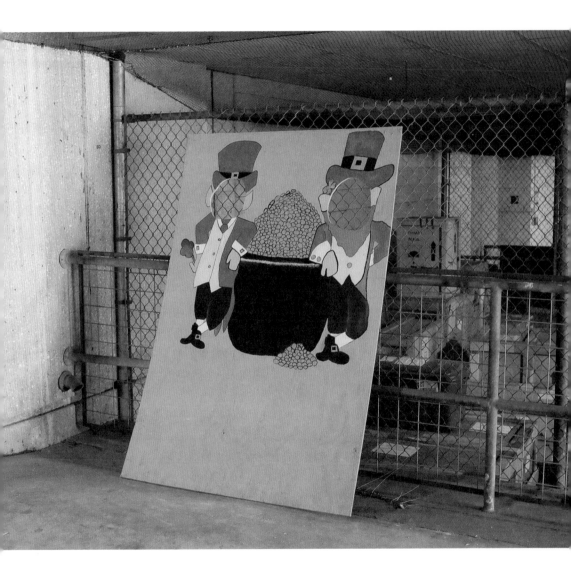

Frances

"The Brazilian figa is a good luck symbol that traces its roots to African slaves who were brought into the country. I was told it holds luck only if it is given to you. My figa was a gift from my Brazilian boyfriend when I turned fifteen. I have had it for forty-six years and have worn it off and on. I feel special when I wear it."

In much of Asia, red envelopes containing money are often given as gifts to unmarried people and children at holidays and significant events. The color red is for luck and to ward off evil spirits.

Tess

"My whole family has worn jade bracelets since we were kids. I have four different ones. The one that I'm wearing I've had on for five or six years. I never take it off. In fact, now I can't. Jade represents luck. It's all about luck. Jade dates back to dynasties. My grandmother has worn hers her whole life. My mom was helping her on the stairs—they live five or six stories up—and she slipped and fell down a flight of stairs. She was in her eighties. My mom was like, 'Oh, no. She's not going to make it!' She thought maybe she broke a hip or something. She ran down to check and her, and my grandma just got up. The jade bracelet was on the floor. It had broken in the fall. It had taken the bad luck that would have been the broken hip or death. When a jade bracelet breaks, it absorbs the bad luck so that you don't get it; it gets it. I told my mom that I love my bracelet so much that even if it breaks I would keep it. She told me not to because it would mean keeping the bad luck. Jade is alive, so every time I rub it, it gets darker."

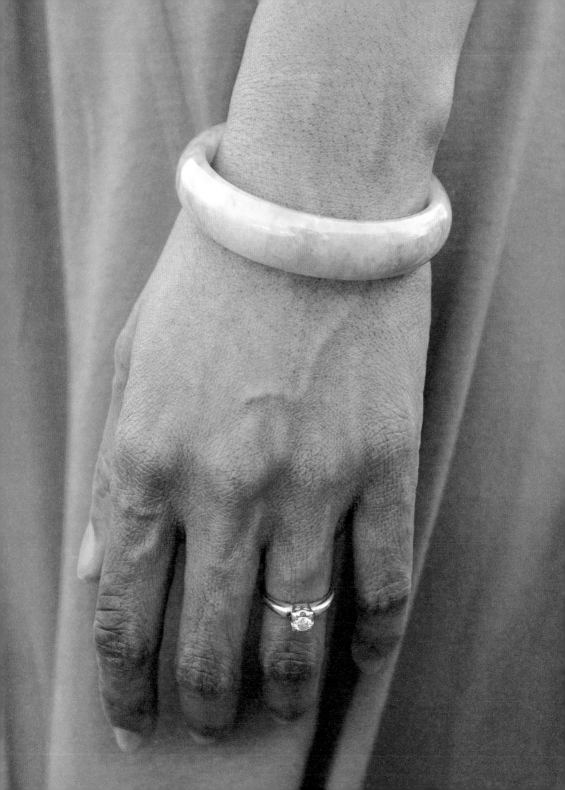

Autumn

"The first day I arrived in Iraq on my second deployment I was taking my bags into my tent when I noticed a St. Christopher's medal on a necklace in the sand. The tent I was moving into was unoccupied at the time, so I knew someone previously deployed there must have left it. I carried that necklace with me for the entire deployment even though I don't believe in luck. I am a Christian and always knew God was looking out for me. I consider my faith my luck. By carrying the medal in my pocket I felt like I could feel God's hand on me whenever I needed it. On the last day we were on the bus to our plane to go home when our base was hit by IEDs. One hit so close to our bus it shook the windows. I felt so blessed, 'lucky' that someone didn't have such great aim. After I got on the plane I realized I couldn't find that necklace. To this day I think maybe it's still over there being someone else's lucky charm."

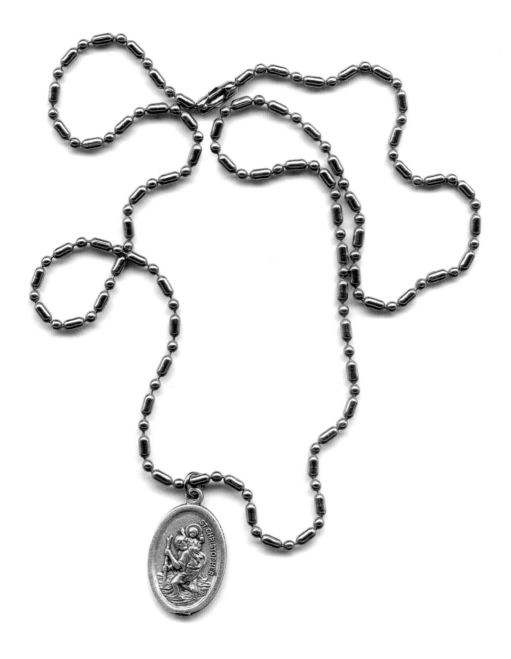

When you find yourself in a difficult situation because of illness, moral crisis, or economic hardship, know that St. Jude Thaddeus is with you. This chain letter has circled the world with devotion to St. Jude. Make 81 copies of this letter and place 9 copies in 9 churches and pray an Our Father and to the souls in Purgatory. This chain letter is being sent by one of the thousands of people in the world; by no means make fun of or interrupt the chain. Send it within 13 days.

INCIDENTS

The president of Brazil sent the chain but didn't give it much attention. On the 13th day he won the lottery. Ezequiel Conar joked about it and asked his secretary to do it and she didn't; on the 13th day he lost his job. Isabel Galvan lost it and was on the verge of aborting her child.

OBSERVE HOW YOUR LUCK WILL CHANGE AFTER 13 DAYS ONCE YOU HAVE SENT THE LETTERS.

Cuando te encuentres en una situacion dificil por
enfermedad, crisis moral o economica debes saber
que San Judas Tadeo te acompana. Esta cadena
da la vuelta al mundo por devocion a San Judas
Tadeo saca 81 copias las depositas en 9 Iglesias (9
en cada una de ellas) rezas un padre nuestro y otro
a las almas del Purgatorio. Esta cadena la envia
una de las miles de personas que hay en el mundo;
por ningun motivo debes burlarte de ella.
Interrumpiendola. Envialas antes de 13 dias.

ANTECEDENTES

El Presidente de Brazil la envio y no le dio
importancia, a los 13 dias se saco la loteria.
Ezequiel Conar la tomo a broma ordenando a su
ecretaria que las hiciera y no las envio, a los 13 dias
perdio su empleo.
sabel Galvan las perdio y estuvo a punto de abortar.

DEBE OBSERVAR COMO CAMBIA LA SUERTE DESPUES DE 13 DIAS DE HABERLAS ENVIADO.

Jenn and Ryan

"When Ryan and I decided to get married, we wanted to incorporate Chinese and Japanese cultural traditions into our ceremony. One that I fell in love with was the Hawaiian Japanese tradition of displaying 1,001 folded origami paper cranes at the wedding reception. The cranes represent longevity, good luck, and well wishes for the married couple."

"Traditionally, the bride folds all 1,000 cranes and the last lucky one for good luck. My mother and family friends lovingly asked to help Jenn with the folding, promising to send the cranes from Hawaiʻi before our wedding reception in San Antonio. The day before our wedding, Jenn frantically watched YouTube videos in hopes of learning how to fold her one lucky crane. Luckily, she persevered and got it done! . . . and married."

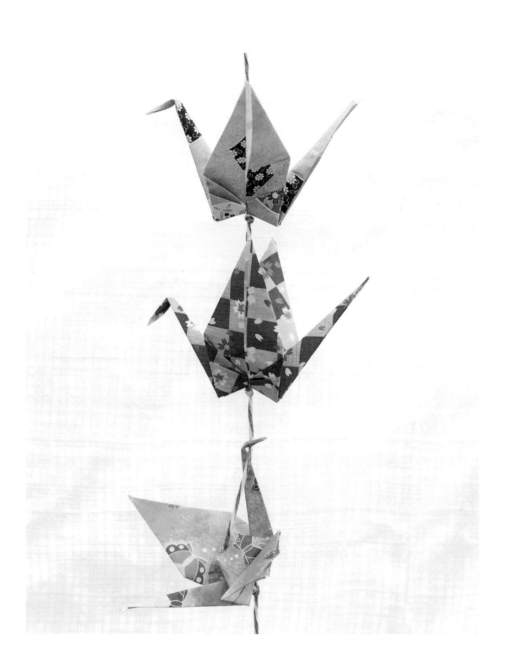

Intersection of Lake Boulevard and Mistletoe Avenue

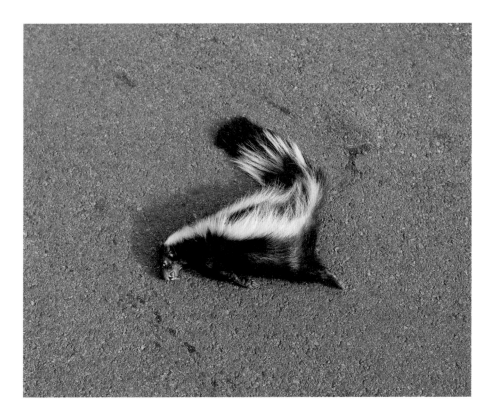

In number theory, a lucky number is a natural number in a set that is generated by a "sieve," similar to the sieve of Eratosthenes that generates prime numbers. Begin with a list of consecutive integers starting with 1. Eliminate every second number, leaving only the odd integers. The second number in the sequence is 3. Eliminate every third number that remains in the list. The third number is now 7, so eliminate every seventh number that remains. When this process has been carried out completely, the survivors are the lucky numbers.

1	3		7	9
	13			
21		25		
31	33		37	
	43			49
51				
	63		67	
	73	75		79
			87	
	93			99

Ranch road, Texas Hill Country

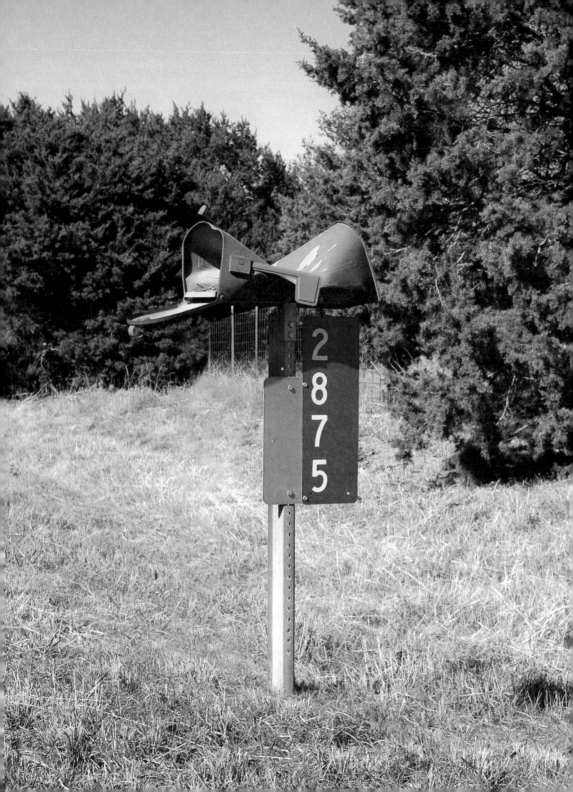

ACKNOWLEDGMENTS

For their support of this project, I would like to thank Harrell Fletcher, Julie Ault, Michael Nye, Bob Maxham, Nolan Calisch, Ben Kinmont, Jordan Baumgarten, Ruth Groeger, Adam Moser, Steve Candelario, Jason Reed, Ben Edgerton, Will and Sally Bryant, Tess Martinez, Ben Judson, Jamie Stolarski, Callie Enlow, Robert Darden, Van Darden, Rich Weimert, San Antonio Missions Baseball, Eliza Gregory, Leslie Moody Castro, Christie Blizard, Tom Payton, Sarah Nawrocki, Andréa Caillouet, and the countless others I have talked to along the way.

For agreeing to be included in this book, I thank Harrell Fletcher, Adrian, Rudy, Susan, Sonia, Sierra, Karina, Adriana, Erica, Cowboy, Jesse Singh, Bubba Pitts, Syler, Rebecca Rosen, Lexa Walsh, Zach Griffin, Alisa, Bob Maxham, Amy, Sara, Jason Reed, Julia Vallera, Aric, Milton Menjivar, Tyler, Katie, Alysha Shaw, Chris, Sebastian, Marvin, Michael, Arion, Jennifer Dobbertin, Paul, Leslie Stem, Lane Collins, Jamie Stolarski, LuLu, Sally Bryant, Jason Sturgill, Adam Moser, Lady Mimi, Ben Judson, Bob Darden, Lee Orr, Mickey, Jeff, Brian, Joe, Steven and Julie Ann, Steve, Noh, the Snack Lady, Jane, Zeke, Michelle, Tony, Sarah Martin, Rachel Menjivar, Patricia, Jorge, Bianca, Denzel, Matt, Angela Coon, Eliza Gregory, Nolan, Nicolette, Frances Menjivar, Tess, Autumn Dean, Jennifer Datchuk, and Ryan Takaba.

A special thank you to everyone who has submitted to the archive over the years. Without you, this project would not exist.

Finally, thank you to my wife, Rachel, and our boys Asa and Eilan. I feel so lucky to get to live life with you.

Published by Trinity University Press
San Antonio, Texas 78212

Book design by Andréa Caillouet

Printed in China

Trinity University Press strives to produce its books using methods and materials in an environmentally sensitive manner. We favor working with manufacturers that practice sustainable management of all natural resources, produce paper using recycled stock, and manage forests with the best possible practices for people, biodiversity, and sustainability. The press is a member of the Green Press Initiative, a nonprofit program dedicated to supporting publishers in their efforts to reduce their impacts on endangered forests, climate change, and forest-dependent communities.

The paper used in this publication meets the minimum requirements of the American National Standard for Information Sciences–Permanence of Paper for Printed Library Materials, ANSI 39.48–1992.

ISBN 978-1-59534-249-2 paperback
ISBN 978-1-59534-250-8 ebook

CIP data is on file at the Library of Congress

19 18 17 16 15 5 4 3 2 1

THE LUCK ARCHIVE is an ongoing exploration of how luck intersects with belief, culture, superstition, and tradition in people's lives. Along the way, Mark Menjivar has documented his findings, creating a publicly accessible archive that contains hundreds of objects, photographs, and stories. He has spent time talking with people on the streets and in airplanes, tattoo shops, bingo halls, international grocery stores, public parks, baseball stadiums, voodoo shops, and homes. The archive contains rings, coins, clovers, charms, patches, underwear, sports superstitions, lottery strategies, day trader insights, animal stories, dolls, games, crystals, seeds, cigarettes, rainbows, and more. For more information or to participate, go to www.theluckarchive.org.

7-15